IMAGES
of America

MERIDIAN HILL PARK

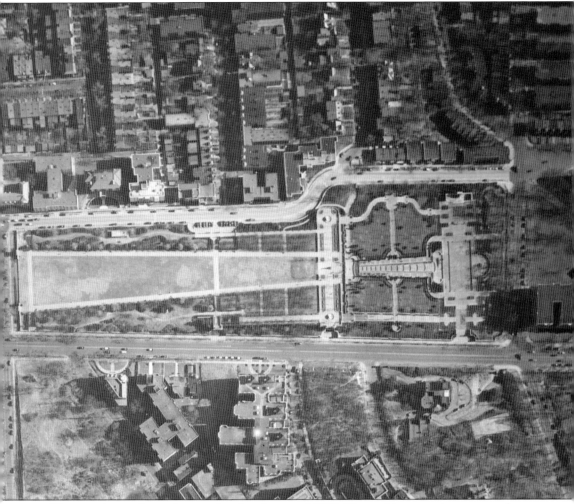

This aerial view shows the completed park around 1932. The park's two main areas can be seen here. The upper park, designed as a mall with promenades and winding walkways, is at left. The lower park, designed in the Italianate style with a 13-basin cascade and a reflecting pool, is at right. (Courtesy of the National Park Service.)

ON THE COVER: A crowd of several hundred gathered in Meridian Hill Park on July 4, 1963, to hear the Watergate Symphony Orchestra present a program of patriotic music in the lower area of Meridian Hill Park. The orchestra, directed and conducted by Dr. Henry Goldstein and made up of 50 resident professionals, was set up between the armillary sphere and the reflecting pool. (Courtesy of the National Park Service.)

IMAGES
of America

MERIDIAN HILL PARK

Fiona J. Clem

ARCADIA
PUBLISHING

Published by Arcadia Publishing
Charleston, South Carolina

Printed in the United States of America

Library of Congress Control Number: 2017931648

For all general information, please contact Arcadia Publishing:
Telephone 843-853-2070
Fax 843-853-0044
E-mail sales@arcadiapublishing.com
For customer service and orders:
Toll-Free 1-888-313-2665

Visit us on the Internet at www.arcadiapublishing.com

This book is dedicated to my parents, Carmel and Bill Clem.

CONTENTS

ACKNOWLEDGMENTS

The author would like to thank the many individuals and organizations whose assistance has aided in the completion of this book. The author thanks the staff at the Rock Creek Park Division of the National Park Service, especially Joshua Torres, cultural resource manager, and the staff at the Museum Resource Center—National Capital Region, National Park Service, especially Tazwell Franklin and Robert Sonderman. Thanks also go to Derek Gray at the Washingtoniana Division of the Martin Luther King Memorial Library, Kay Fanning at the Commission of Fine Arts, and the staff at the Library of Congress Prints and Photographs Division for their help with research and resources. I am also grateful to the valuable input provided by Monica Clem and Paul Arsenault, both of whom took the time to review this text and provide suggested changes. Thanks go to my parents, Carmel and Bill Clem, who instilled in me a sense of curiosity and a love of history. Many of the images were provided courtesy of the National Park Service, acknowledged with NPS, or the Library of Congress, acknowledged with LOC, unless otherwise noted.

INTRODUCTION

Meridian Hill Park, also sometimes referred to as Malcolm X Park, was one of the first public parks in the United States to be designed as a formal, public park. Situated in the middle of Northwest Washington, DC, one and a half miles directly north of the White House, Meridian Hill Park is one of the most unique parks in the National Park system. It is of both cultural and local significance due to its design and location. It was listed in the National Register of Historic Places on October 25, 1974, and was made a National Historic Landmark on April 19, 1994. Within the landscaped 12-acre park are four statues and memorials (originally there were five), and a 13-basin cascade that is one of the longest cascading fountains in North America.

The name of the hill goes back to 1814 when Commodore David Porter arrived in Washington after the War of 1812 and purchased 110 acres for his estate. In 1819, he built a mansion on the grounds and called it Meridian Hill in reference to the then official meridian of the new nation that ran through the area.

The Meridian Hill estate changed hands several times and was subdivided after the Civil War. The area was home to the 19th century nature poet Joaquin Miller, a Civil War encampment and hospital area, and a seminary. In 1910, Congress bought 12 acres of land formed by Sixteenth Street NW on the west, Fifteenth Street NW on the east, W Street NW on the south, and Euclid Street NW on the north, with the intention of creating a park.

The idea of a park at the site began with the McMillan Plan (formally "The Report of the Senate Park Commission"), which suggested a park on both sides of Sixteenth Street at Meridian Hill in recognition of the site's panoramic views.

A principal advocate for the park was Mary Foote Henderson. She and her husband, Sen. John Brooks Henderson, lived in the neighborhood, and she invested in land, built mansions, and enticed embassies to the neighborhood. She owned some of the land that became Meridian Hill Park, and in 1910, Congress approved the purchase and bought the 12 acres for $490,000. In the subsequent years and until her death in 1932, Mary Foote Henderson continued to advocate for funds from Congress for the completion of the park.

The design of the park was influenced by the Commission of Fine Arts, and construction was overseen by the Office of Public Buildings and Grounds. The Commission of Fine Arts was created in 1910 by Congress to advise the government on, among other things, the architectural development of Washington, DC.

The original plans for the park were designed by George Burnap, a landscape architect who was employed with the Office of Public Buildings and Groups. The plans were approved by the Commission of Fine Arts in 1914. Burnap was replaced as chief architect in 1917 by Horace W. Peaslee. Peaslee had studied landscape architecture under Burnap at Cornell, and had come to Washington to work with Burnap. He stayed true to much of the Burnap design.

The design team also included Ferruccio Vitale of Vitale, Brinckerhoff and Geiffert, who was an Italian-American landscape architect and designed the planting plans for the park,

and John Earley of Washington, who perfected the architectural concrete used throughout the park.

The park is divided into two primary areas: the lower park, with its 13-basin cascade of linked basins, symmetric stairways, and a large reflecting pool surrounded by a plaza; and the upper park, with an open mall surrounded by wooded areas and a broad terrace overlooking the lower park. The mall is evocative of French gardens, and the water feature and *boscos*, or dense groves, of the lower park are reminiscent of Italian villas.

Five important monuments and memorials were placed in the park. A statue to Dante Alighieri was the first, dedicated in 1921. In 1922, a statue of Joan of Arc was placed in the middle of the upper level's grand terrace. A marble allegorical figure of Serenity was installed in 1925. The Buchanan Memorial was one of the first planned, although it was not dedicated until 1930. The last memorial placed in the park was the Noyes armillary sphere in 1931.

Development of the park began in 1915. One of the first elements to be completed was the Sixteenth Street retaining wall. John Earley of The Earley Studio was contracted to create the walls, originally using stucco. The finish proved to be unacceptably dull. Earley then worked on perfecting an aggregate concrete finish, which he accomplished by changing the process in which the concrete was created and finished. The process, which Earley referred to as "architectural concrete," was used throughout the park for the walls, balustrades, staircases, benches, and basins.

The planting plan created by Ferrucio Vitale was also ambitious, and although not fully implemented, has been crucial to the beauty and effectiveness of the park. Trees define the mall of the upper park and weave along the secondary pathways, creating a sense of privacy and seclusion. The boscos of the lower park were not realized. But the cascades are lined with flowers and hedged with American holly, the walkways reinforced with hedges, and the hillside filled with dogwoods and other flowering trees.

Meridian Hill Park is a successful combination of architectural concrete and plantings that takes advantage of its location and view. The park was officially opened on September 26, 1936, having taken more than 26 years and over $1.5 million to complete.

In the years since the park was opened, it has been the site of a series of concerts before and after World War II including performances by the Trapp Family Singers and Martha Graham, the site for one of the longest running drum circles every Sunday since the 1960s, a site for civil rights protests in the 1970s, a site for drug use and other criminal activities in the 1990s, and now, after the formation of the Friends of Meridian Hill and years of renovation and rehabilitation, a very beautiful, and busy, neighborhood park.

One

FROM L'ENFANT
TO McMILLAN
1790–1910

From the founding of the nation's capital in 1790 until 1910, when Congress purchased the land, the area that became Meridian Hill Park was home to many prominent people. The land was home to a naval hero, a US president, Civil War encampments and hospitals, well-known poets, a national university, a seminary, and for the past 80 years, a park.

At the founding of the city of Washington, much of the land in the area that became Meridian Hill was owned by the Peter family, prominent, wealthy, and extensive landowners in the area. In 1814, Commodore David Porter arrived in Washington after the War of 1812 and purchased 110 acres from the Peter family. In 1819, he erected a mansion on the grounds and called it Meridian Hill. During the planning for the new capital, surveyor Andrew Ellicott and Pierre Charles L'Enfant had laid out a prime meridian for the new nation under the direction of Secretary of State Thomas Jefferson. The meridian ran through the President's House (White House) and north through the area that would become Meridian Hill.

The Porters lived at Meridian Hill until the late 1820s. J. Florentius Cox bought the estate and lived there until his death in 1858. Col. Gilbert L. Thompson, who owned it during the Civil War, sold the property in 1867 to Isaac Messmore, who had the land subdivided. The mansion was destroyed by fire in 1873.

With Reconstruction came population growth and expansion outside Washington City. In 1888, former senator John B. and Mary Foote Henderson moved into their newly built mansion at the corner of Sixteenth Street and Boundary Road (now Florida Avenue NW). Then, in 1901, the McMillan Plan for the city included the suggestion of a park on either side of Sixteenth Street just north of Florida Avenue. Mary Foote Henderson lobbied Congress for many years to authorize the purchase of land for the construction of a park, and in 1910, Congress bought the 12 acres for $490,000.

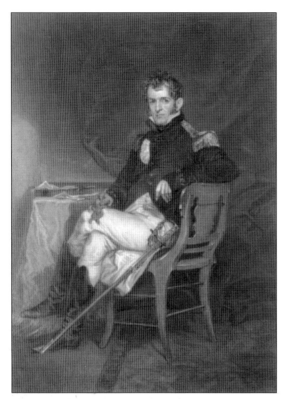

In 1814, Commodore David Porter bought the 110 acres that now include Meridian Hill Park when he came to Washington after the War of 1812. He built a house overlooking the White House and called it Meridian Hill. Commodore Porter was married to Evalina Anderson and had 10 children, including two sons, Adm. David D. Porter and Adm. David Farragut. The Porter family lived at Meridian Hill until the late 1820s. In his 1875 *Memoir of Commodore David Porter, of the United States Navy*, the commodore's son David D. Porter described life on the hill: "Here was to be found everything that money could procure, to make the time pass pleasantly after the life of toil and warfare through which Captain Porter had passed; here he delighted to dispense that hospitality, which made his house a place of reunion for some of the wisest and greatest in the land." (Both, LOC.)

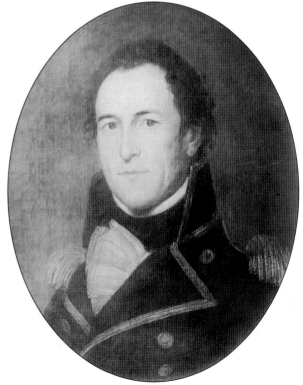

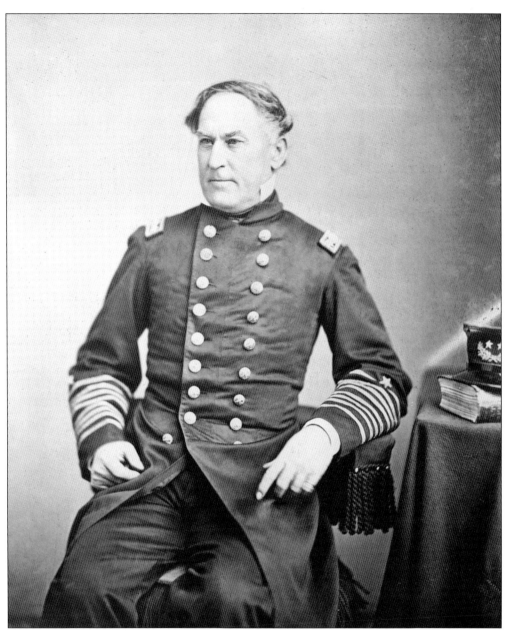

Adm. David Dixon Porter (1813–1891), son of Commodore Porter, grew up in Washington on Meridian Hill. He was the second US Navy officer to attain the rank of admiral, after his brother. In his memoir of his father, he wrote: "Comdr. Porter, accordingly, purchased a farm of 157 acres [sic] on the heights about 1-mile due north of the President's House which, being directly on the meridian of Washington, he called Meridian Hill. Here he erected a large and elegant mansion overlooking the city of Washington and the broad Potomac. . . . The chain of hills, on which the house was built, forms an amphitheater around the city, and the hills were, at the time, covered with a fine growth of forest, the whole forming an extensive landscape which, to this day, has lost little of its beauty." (LOC.)

David Glasgow Farragut (1801–1870) was born James Glasgow Farragut. After his mother died in 1808, Commodore David Porter adopted him. He later changed his name to David to honor his adoptive father. Farragut served in the War of 1812 and the Civil War. Promoted to admiral in 1886, he was the first US Naval officer to hold that rank. Farragut Square, one mile south of Meridian Hill Park, is named for him. (LOC.)

This statue of Adm. David G. Farragut is located one mile south of Meridian Hill Park at Fifteenth and I Streets in Farragut Square. It was the first monument in Washington, DC, to honor a Naval war hero. Vinnie Ream, a female sculptor, created the statue, and it was dedicated in 1881. The statue was made with bronze from Farragut's Civil War ship the USS *Hartford*. (LOC.)

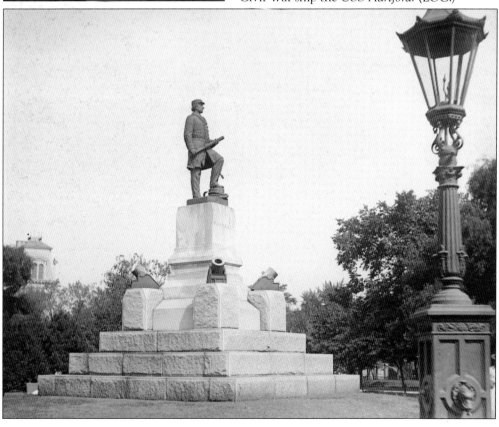

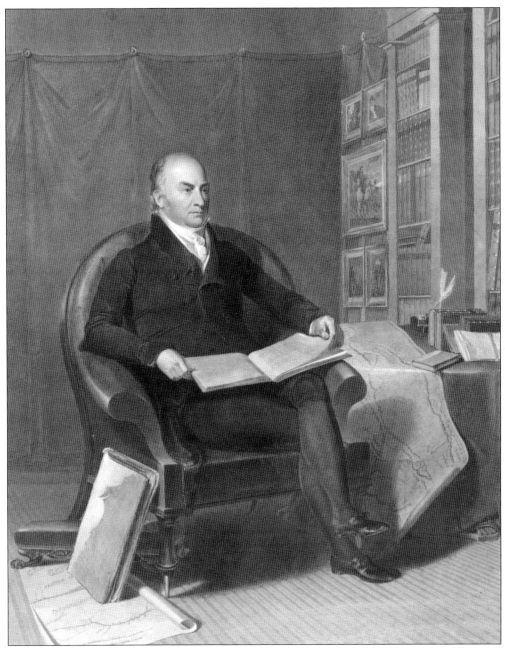

After losing his reelection bid to Andrew Jackson in 1828, John Quincy Adams moved from the President's House to Meridian Hill in March 1829. Adams wrote in his diary on March 3, 1829, that at "about 9 in the evening I left the President's house, and, with my son John and T.B. Adams, Jr., came out and joined my family at Meridian Hill. Dined. Received and accepted the resignations of Richard Rush, P.B. Porter, E.L. Southard, and William Wirt." Although Adams spent most of the summer in Quincy, Massachusetts, his wife, Louisa, was in Meridian Hill. On July 12, Louisa wrote to Adams, "The property here is sold and I received a notice to the 9th to remove on the 1st of August." The new owner, J. Florentius Cox, moved in by August 1, and the Adamses then went to Georgetown and stayed with their son John. (LOC.)

Listed in the *Daily Union* in 1847, this advertisement for the sale of Meridian Hill gives details of the Porter mansion. The advertisement describes the house as "brick and stuccoed . . . 90 feet front, and 54 feet deep, 1½ stories high, with a portico 54 by 12 feet." The Porters sold the property in the late 1820s, and the Meridian Hill mansion burned down in 1867.

Columbian College, which later moved to Foggy Bottom and became a part of George Washington University, was on Meridian Hill from 1821 until 1873. This image shows the main building that held dormitories and classrooms. The smaller building at right was housing for professors. During the Civil War, many of the students left campus and joined the Confederacy. (George Washington University.)

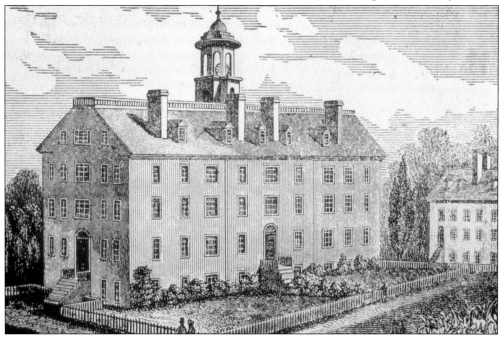

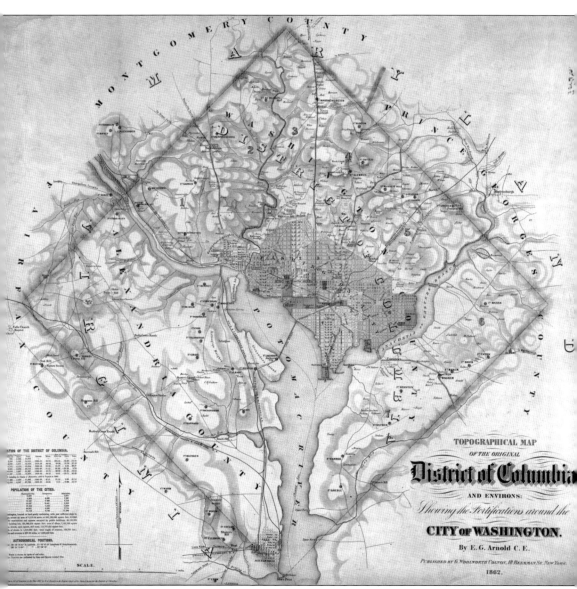

This relief map of the original District of Columbia was published in 1862, and shows the fortifications during the Civil War. The curving line around Washington City is Boundary Road. Also shown on the map is the area of Meridian Hill and the nearby Civil War hospitals, including the hospital at Columbian College and Carver Hospital. (LOC.)

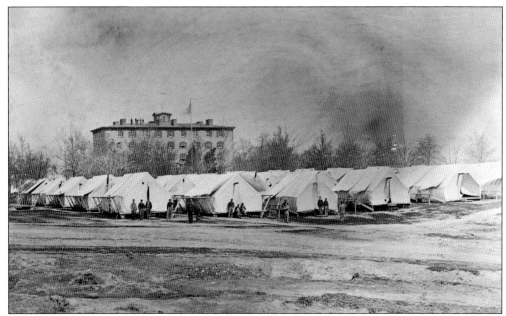

During the Civil War, the area around Meridian Hill changed dramatically. The Union forces commandeered land, public buildings, large private homes, and academic institutions. The students at Columbian College left Washington, and many joined the Confederacy; the college's buildings were used as barracks and a hospital. The area around the college became known as Carver Barracks and Campbell Hospital. (LOC.)

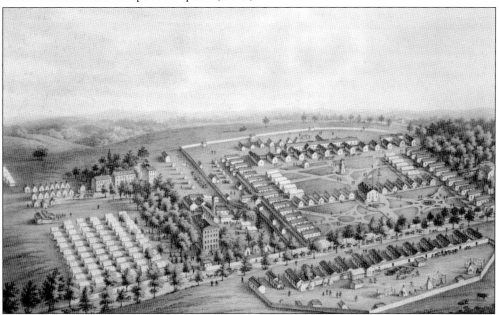

Occupants of Meridian Hill and Columbian College campus included the 3rd Maine Regiment of Volunteers. Within the campus, the Columbian College and Carver hospitals were established. Carver had 1,300 beds, and Columbian College had 844. This print by Charles Magnus shows Columbian College and Carver Barracks in 1864. During the war, Walt Whitman devoted time to the patients at Carver Hospital. (Courtesy of George Washington University.)

Walt Whitman (1819–1892), the poet and author of *Leaves of Grass*, came to Washington, DC, to give aid to a group of wounded soldiers in December 1862. Whitman decided to remain in Washington, tending to the sick and writing articles for the *New York Times* and the *Brooklyn Daily Eagle*. He spent time at many hospitals in the city, including Carver Hospital. (LOC.)

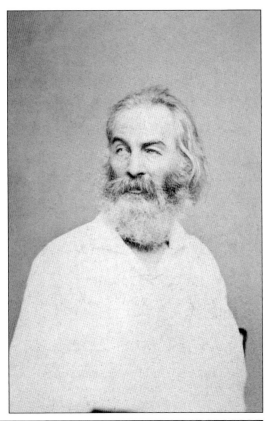

Many New Jersey regiments camped on Meridian Hill during the Civil War. This drawing of the camp barracks was done by George H. Durfee of Company K of the 1st New Jersey Regiment on May 27, 1862. Most of the New Jersey regiments stayed on Meridian Hill from December 1861 before moving out in May 1862 and eventually fighting in the Battle of Bull Run in July 1862. (George Washington University.)

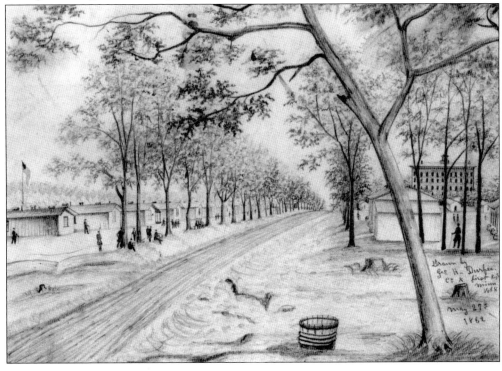

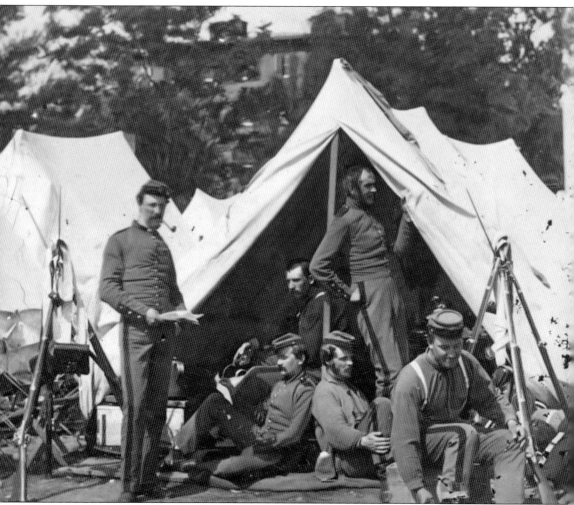

The 7th Infantry of New York were the first from that state to reach Washington after Lincoln's call for troops. They made camp on Meridian Hill in May 1861. There were many encampments on Meridian Hill. Surgeon George T. Stevens of the New York 77th also encamped there. In his book *Three Years In The Sixth Corps: A Concise Narrative Of Events In The Army Of The Potomac From 1861 To The Close Of The Rebellion, April 1865,* he wrote: "We encamped on Meridian Hill December 1, 1861, with 960 men. Meridian Hill is the most delightful locality in the vicinity of Washington. . . . [It] had been the residence of Commodore Porter, and the house still bore the name of 'the Porter Mansion.' . . . The mansion itself became our hospital, and for a time also served as our head-quarters." (LOC.)

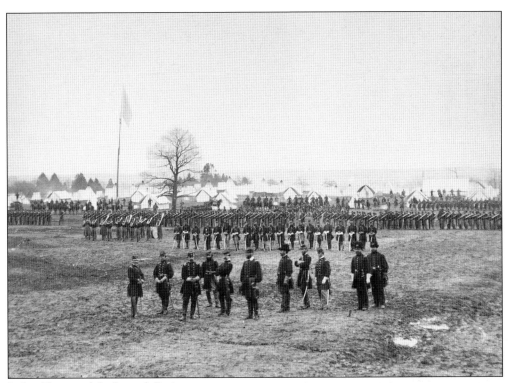

In his *History of the Seventh Regiment, National Guard, State of New York, During the War of the Rebellion*, William Swinton described Camp Cameron: "The new camp had been christened, by Colonel Lefferts, 'Camp Cameron,' in honor of the Secretary of War, and by that name it has passed into history. Situated on Meridian Hill, a mile out on Fourteenth Street, and opposite Columbia College, the camp was both healthy and beautiful. The headquarters commanded a view of the Potomac, as well as of the capital, and of Arlington Heights beyond." Robert Gould Shaw (1837–1863), seen at right, served with the 7th New York Militia and stayed at Camp Cameron in 1861. In 1862, he accepted command of the 54th Massachusetts Infantry, the first all-black regiment. Shaw died fighting with the 54th Massachusetts in the Battle of Fort Wagner in South Carolina. The Washington neighborhood of Shaw is named in honor of him. (Both, LOC.)

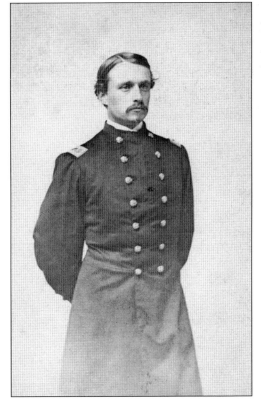

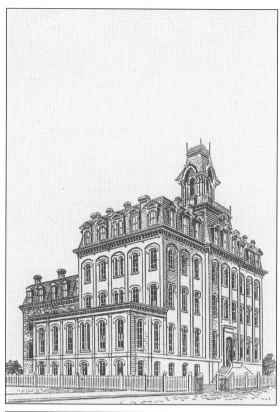

Established after the Civil War by the American Baptist Home Mission Society, Wayland Seminary was located near Fifteenth and Euclid Streets. The main building, Parker Hall, was completed in 1876. It included dormitories, classrooms, and Coburn Chapel. The school was named after Dr. Francis Wayland, a former president of Brown University and anti-slavery leader. Designed primarily for educating African American freedmen as ministers, the seminary eventually offered courses and programs at all levels to both men and women. Wayland Seminary was located on Meridian Hill until 1899, when the seminary and Richmond Theological Seminary merged into Virginia Union University at Richmond, Virginia. During the 30 years that Wayland Seminary was located in Washington, many of the students who studied there became well-known, including Booker T. Washington (1856–1915), seen below. (Left, courtesy of Virginia Union University; below, LOC.)

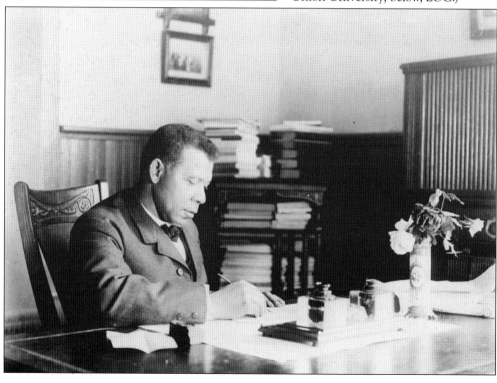

Joaquin (born Cincinnatus) Miller (1837–1913) was a well-known writer and poet. After publication of his poetry book *Songs of the Sierras*, he gained the nickname "Poet of the Sierras." Miller moved to Washington, DC, in 1883 and built a cabin in the area of Meridian Hill. In her memoir *American Court Gossip, or Life at the National Capitol*, E.N. Chapin recounted a visit to Miller's cabin: "Joaquin Miller, the poet of the Sierras, invited members of the press one evening, to see his new log cabin on Meridian Hill, and the odd-looking domicil [sic] among the fine residences was a curious sight, and it proved a sure enough cabin, being made of pine logs from a Maryland forest, not far away. There are three rooms— parlor, bed-room and kitchen, furnished with handsome rugs, portieres of dark stuffs, rural chairs, buffalo robes, 174 the antlers of deer—on the bed, bear skins, and an eider down quilt. A Mexican saddle was in a corner, a bowie knife on his toilet table, and other furniture of a western cabin." (Both, LOC.)

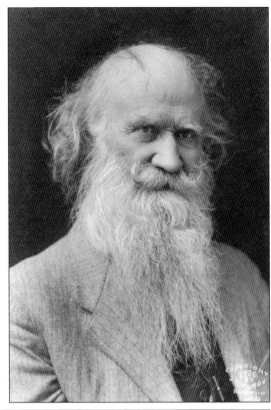

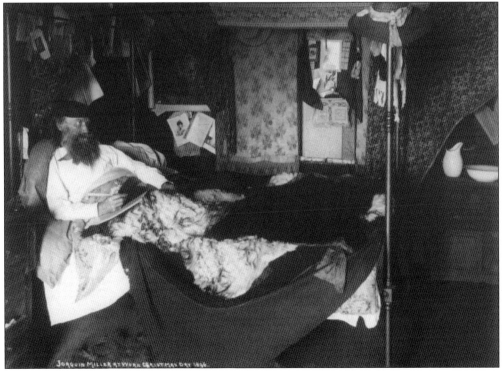

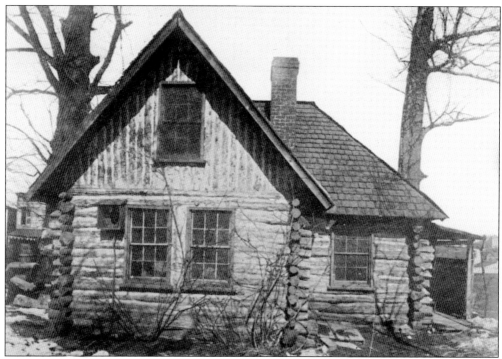

Joaquin Miller built this cabin at Belmont and Sixteenth Streets in 1883 and used it for four years. Hamlin Garland, in his 1930 memoir *Roadside Meetings*, recounted a story of Washington life told to him by Miller: "[I] made that my home for four years, but I was away much of the time. I didn't like it there. Congressmen . . . wore me out. They all came to Washington as the great men in little towns, and their women, raw, silly, curious, had nothing better to do than to seek out Joaquin Miller, 'the man who lived in a tree.' They made life miserable for me and I fled." After he left, the cabin was unused for years. The land was purchased in 1911, and the cabin was slated for demolition. The California Society in Washington, DC, paid to dismantle and move the cabin to Rock Creek Park in 1912. Today, the cabin sits near picnic area No. 6, close to the corner of Military and Beach Drives. (Both, LOC.)

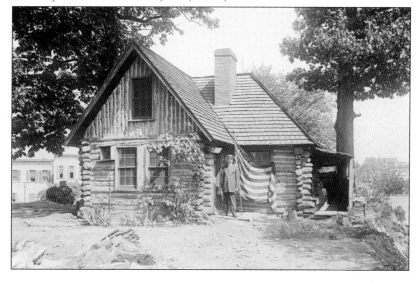

After the Civil War, Hall & Elvans subdivided the area of Meridian Hill. This map shows the details, including the locations of the Meridian Hill mansion and Columbian College, of the newly laid-out Meridian Hill neighborhood. The map, from the *Real Estate Directory of the City of Washington, D.C.* from 1873, also shows the proposed extension and straightening of Sixteenth Street. (LOC.)

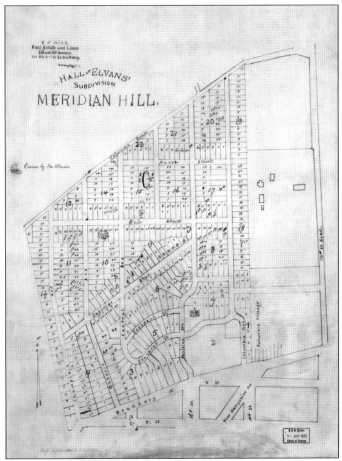

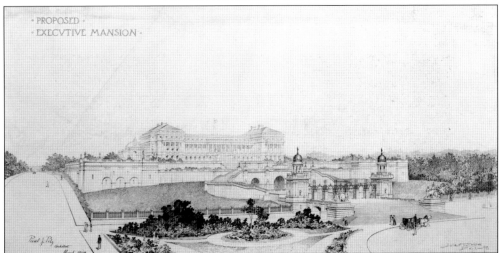

In the 1890s, there was push to rebuild the White House. Several designs for a new executive mansion were proposed. Mary Foote Henderson also commissioned a design for a new mansion that would sit on Meridian Hill. Paul Pelz, who had been part of the design team for the Library of Congress's Thomas Jefferson Building, conceived of this design in 1898. (LOC.)

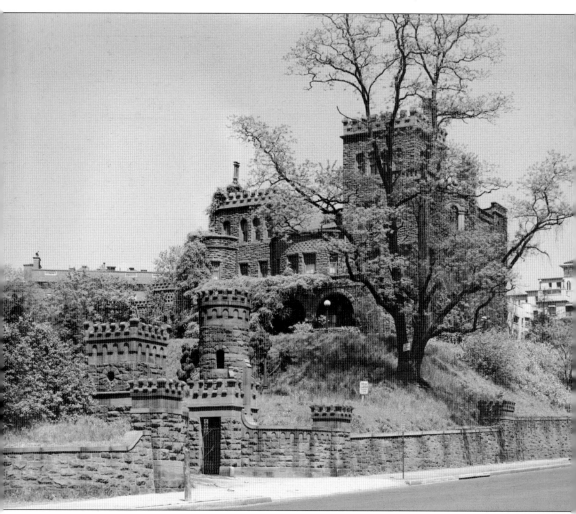

Former senator John B. Henderson and his wife, Mary Foote Henderson, moved into Henderson Castle, also known as Boundary Castle, in 1888. She was influential in changing the Meridian Hill neighborhood. The Hendersons bought land around the hill in order to develop it, and held influence over the growth of the neighborhood for almost 40 years. Mary Foote Henderson was instrumental in getting funding to complete the park. Boundary Castle was located at the corner of Sixteenth Street and Boundary Road (Florida Avenue) and was the first mansion to be built in the neighborhood after the Civil War. According to Sue Kohler in *Sixteenth Street Architecture*, Boundary Castle was "built in several stages although later construction consisted for the most part of remodeling and service additions. Senator Henderson hired E.C. Gardner to design the Seneca brownstone in 1888. In 1892, the architect, T.F. Schneider, added a large picturesque service and stable wing." In 1902, George Oakley Totten Jr. was hired to remodel the castle. Totten and Mary Foote Henderson would work together on many other house projects. (LOC.)

Two

People and Statuary

Designing the Park

Congress approved the purchase of the park land on Meridian Hill in 1908 and bought the 12 acres of land in 1910. The plans for the park were finalized in 1914 and planning and construction began in 1916. The park was completed in 1936, becoming part of the National Park Service in 1933.

The original designer of the park was George Burnap, who was inspired by the gardens of Italian and French villas. Because of his vision, Meridian Hill Park's Neoclassical design sets it apart from other public parks in the United States.

In 1917, landscape architect Horace Peaslee replaced Burnap and remained as lead architect of the park until its completion. Peaslee simplified the elaborate formal gardens of the upper portions of the park and replaced them with an open mall, and created the extensive monumental walls and fountains built of exposed aggregate in varying colors and textures.

The construction of the park relied on advanced techniques and materials. The terraces, walls, and pavements were rendered in pre-cast and cast-in-place concrete treated in a variety of ways. The concrete contractor, John J. Earley, was a highly skilled craftsman who perfected the concrete aggregate technique used throughout the park. The elaborate planting plan was created by Feruccio Vitale.

Five important monuments and memorials have been placed in the park. A statue to Dante Alighieri was the first statue in the park, dedicated in 1921. In 1922, a statue of Joan of Arc was placed in the middle of the upper level's grand terrace. A marble allegorical figure of Serenity was installed in 1925. The Buchanan Memorial was one of the first planned, although it was not dedicated until 1930. The last memorial placed in the park was the Noyes armillary sphere in 1931. It was commissioned by Bertha Noyes, created by sculptor Carl Paul Jennewein, and bequeathed to Washington, DC, in memory of Noyes's sister.

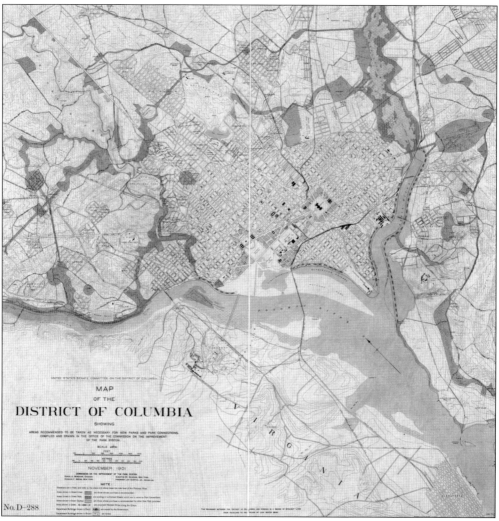

In 1900, Sen. James McMillan created a committee to study the design and development of Washington's public buildings and parks. In 1901, the Senate Park Commission was formed. Its members included architects Daniel Burnham and Charles McKim, landscape architect Frederick Law Olmsted Jr., and sculptor Augustus Saint-Gaudens. The McMillan Commission report, published in 1902, included plans to create and extend parks to protect views and natural features. This map from November 1901 shows "public reservations and possessions and area recommended to be taken as necessary for new parks and park connections, compiled and drawn in the office of the commission on the improvement of the park system," and includes a park reservation at Meridian Hill. In 1910, Congress purchased the land that would become Meridian Hill Park. When the land was purchased, it was with the intent that Meridian Hill Park be developed to be of benefit to all the people of the United States. (LOC.)

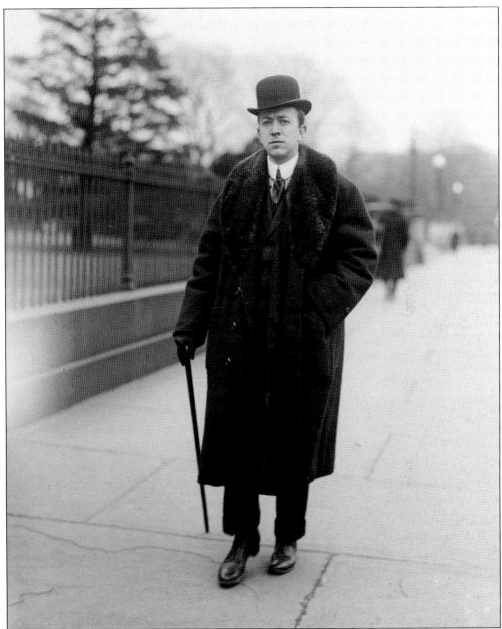

George Burnap (1885–1938) created the first plan of Meridian Hill Park in 1914. Burnap, born in Massachusetts, studied architecture and landscape architecture at the Massachusetts Institute of Technology, Cornell, and the University of Paris. He was also a fellow at the American Academy in Rome. He came to Washington to work as a landscape architect for the Office of Public Buildings and Grounds from 1912 to 1917. In his 1916 book *Parks: Their Design, Equipment and Use*, Burnap wrote that a neighborhood park "should permit perfect relaxation on the part of those who frequent it. Its design and material should be agreeable and pleasing to the eye: its convenience ample and ministering to the general comfort of its users." When he resigned, Horace Peaslee took over as lead architect for the park. Burnap's original plan informed the park development for the next 20 years, despite some general simplifications. (LOC.)

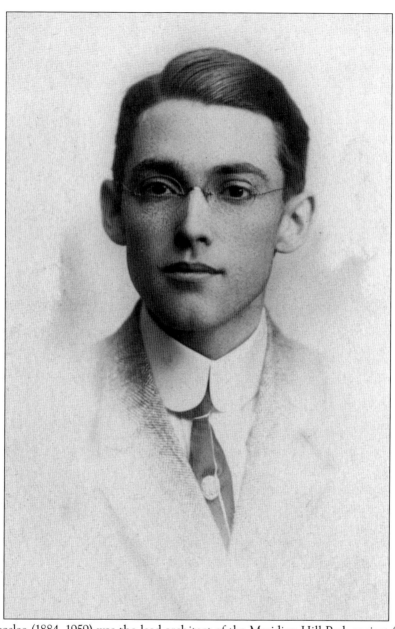

Horace Peaslee (1884–1959) was the lead architect of the Meridian Hill Park project from 1917 until 1935. Peaslee was born in New York and graduated from Cornell University, where he studied architecture under George Burnap. In 1912, Peaslee came to Washington to work in the Office of Public Buildings and Grounds with Burnap. In 1914, Peaslee, Burnap, and several members of the Commission of Fine Arts went to Europe to study park design. This trip was extremely influential to Peaslee's growth as a landscape architect. In 1917, Burnap returned to private practice, and Peaslee was named lead architect of the Meridian Hill Park project. Two major design revisions took place under Peaslee: the first in 1920 and the second in 1928. Both revisions simplified the park plans but remained true to Burnap's design esthetic. Peaslee remained interested and involved with the park throughout his life, communicating with the Commission of Fine Arts about suggestions for improvements. He died in Washington in 1959. (Courtesy of Cornell University.)

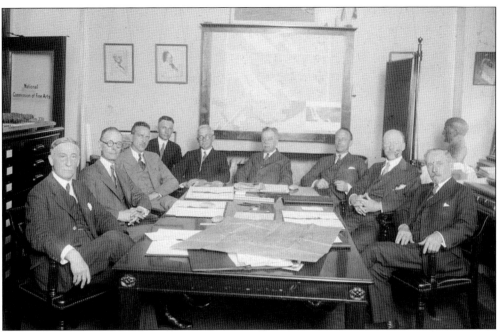

The Commission of Fine Arts was created in 1910 by Congress to advise the government on arts and national symbols as well as the architectural development of Washington, DC. In 1914, Horace Peaslee, George Burnap, and members of the Commission of Fine Arts traveled to Spain, France, Switzerland, and Italy to study European gardens. This trip influenced George Burnap and his original design of Meridian Hill Park. (LOC.)

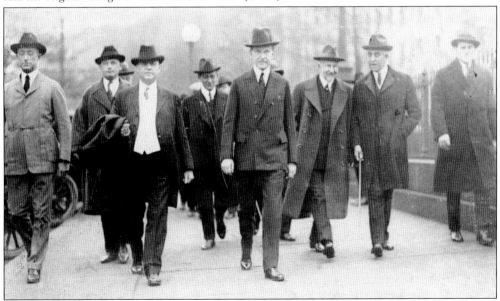

Feruccio Vitale (1873–1933), born in Florence, Italy, trained as an engineer before working in landscape architecture. He moved to New York City and established his practice Vitale, Brinckerhoff and Geiffert in 1908. In 1919, he became chief landscape designer for the park. In 1927, Vitale was appointed to the Commission of Fine Arts (pictured here) by Pres. Calvin Coolidge and continued to take an active role in the development of the park. (LOC.)

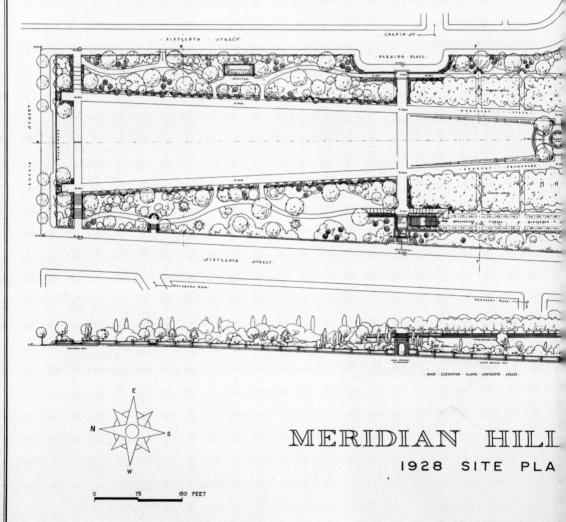

PLAN·OF·MERIDIAN·HILL·PARK·WASHINGTON·D.C.

Designed in the Office of Public Buildings and Grounds, Colonels W.W. Harts and C.S. Ridley successively in charge,
By Horace W. Peaslee, Architect, with Planting Composition by Vitale, Brinckerhoff and Geiffert, Landscape Architects, and
According to the Recommendations of the Commission of Fine Arts, Developed from the Original Design of George Burnap.

MERIDIAN HILL
1928 SITE PLA

0 75 150 FEET

30

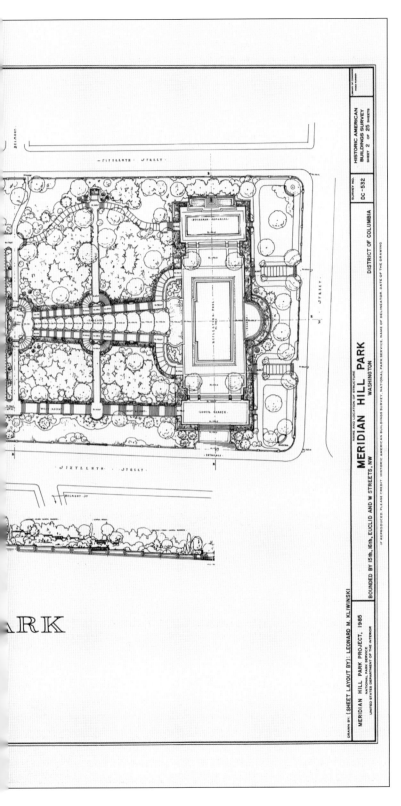

George Burnap's original park plan had been approved by the Commission of Fine Arts in 1914. In 1917, Horace Peaslee assumed the role of architect and modified the plan. In 1928, a simplified plan (shown here) was submitted and approved by the commission. The original plans had included a parking area in the upper park, a bridge across the cascades in the lower park, and a second entrance to the grand terrace from Sixteenth Street; these were eliminated in the final plan. The concert *tempietto* is still part of the design near the grand terrace, although it is smaller than first proposed; it was never completed. This plan also includes the staircases of the grand terrace that were not in the original plan. The Buchanan statue is also included in this plan. (Courtesy of the Commission of Fine Arts.)

John Joseph Earley (1881–1945) was born into a family of stone carvers who taught him sculpture, model making, and stone carving. After his father's death in 1906, Earley took over his father's Washington, DC, studio. He and his business partner, Basil Taylor, changed the focus of the studio from sculpture and stone carving to plaster and stucco. The studio was well-known in Washington and did work on several government contracts. In 1915, Earley was contracted to work on the Sixteenth Street retaining wall at Meridian Hill Park. The contract called for the use of stucco, but the finish was decidedly dull. That led Earley to work on an aggregate process, which he perfected and called architectural concrete. Earley states in his article, "Some Problems in Devising a New Finish for Concrete," that the monotony of appearance was changed by finishing with various details in different textures. The color was changed by using pebbles of the same color and dimensions, and different aggregate was used on different panels to vary the textures. This process was extremely successful and used throughout the park. (LOC.)

Mary Foote Henderson (1841–1831) was crucial to the development of the park. She and her husband, Sen. John Brooks Henderson, moved into Henderson Castle, also known as Boundary Castle, in 1888. The neighborhood, just outside of the original boundary of the city of Washington, afforded opportunity for development. The Hendersons bought property, built mansions, and tried to entice embassies to the neighborhood. Although they were not always successful, the French Embassy did occupy 2460 Sixteenth Street for almost 20 years. After the 12 acres of land was purchased by Congress, Mary Foote Henderson lobbied to get the Lincoln Memorial built on the hill, and had John Russell Pope prepare a design for it, which was rejected. After the Neoclassical Italianate park design was approved by the Commission of Fine Arts, Henderson became a champion for the park. From 1915 until her death in 1931, she was a constant supporter of the park and lobbied Congress for funds for the park to be completed. After her death, a memorial was proposed, but it was never completed. (LOC.)

John Brooks Henderson (1826–1913), a US senator from Missouri from 1862 to 1869 and a co-author of the Thirteenth Amendment to the US Constitution, was married to Mary Foote Henderson. In 1888, the two moved into Boundary Castle, where he lived until his death in 1913. He was a writer and supported his wife's efforts to effect change in the neighborhood. (LOC.)

George Oakley Totten Jr. (1866–1939) was a prominent architect who worked with Mary Foote Henderson designing mansions around Meridian Hill. He graduated from Columbia University and studied at the Ecole des Beaux Arts in Paris. In 1923, Totten rescued the H.H. Richardson Warder Mansion (located at 1515 K Street) and added it to his property at 2633 Sixteenth Street. Totten married Vicken von Post, as pictured here in 1921. (LOC.)

The memorial to Dante Alighieri was the first statue placed in Meridian Hill Park. It was dedicated in 1921 on the 600th anniversary of Dante's death. The statue was given to the United States by Carlo Barsotti, president of the Dante Commission of New York. Created by Italian Ettore Ximenes, it is a replica of the Dante statue in New York City. The statue is 12 feet high, and the pedestal is 9 feet high. It shows Dante wrapped in a long cape with his book *Divine Comedy* under his arm. It stands halfway down the hill on the east side of the lower park. Located in what was originally referred to as "Poet's Corner" on the east side of the lower park, the statue is situated at the side of a walkway, with benches surrounding it. (Both, LOC.)

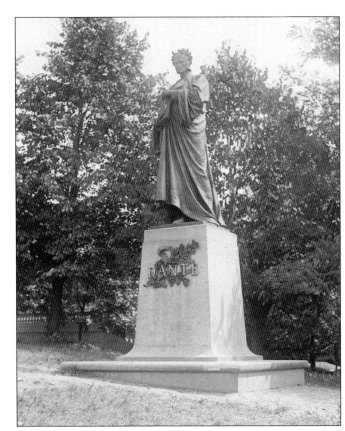

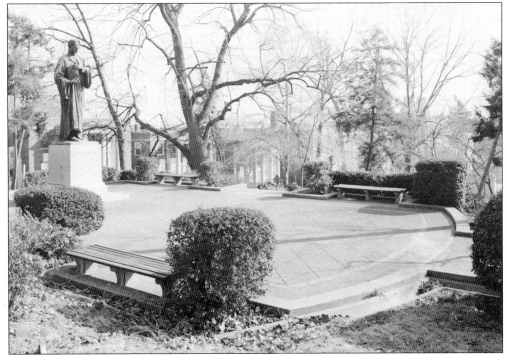

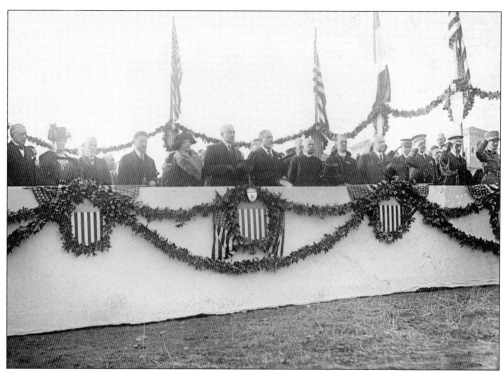

The dedication ceremony for the Dante memorial was held on December 1, 1921. The schedule was changed to accommodate participants of the European delegation who were in Washington for a post–World War I conference on the limitation of armaments. Addressing the crowd was Rene Viviani, former French premier. Also on hand were Italian ambassador Roland Ricci and French ambassador Jules Jusserand. Pres. Warren G. Harding was in attendance along with delegates from the recently concluded arms conference. The dedication ceremony took place before the lower park was complete. In the image below, looking east toward the Dante statue, the undeveloped hill is visible. In the background at right are the spires of St. Augustine, the oldest African-American Catholic church in the nation's capital. (Both, LOC.)

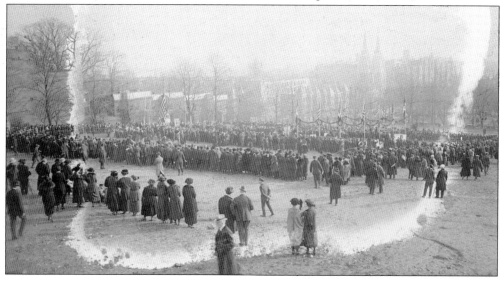

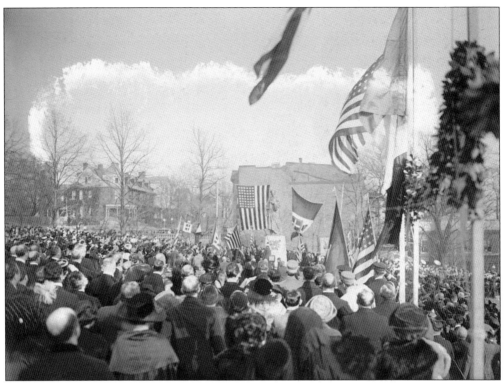

Thousands of members of Italian societies of Baltimore, Philadelphia, and New York came to Washington for the Dante dedication ceremony. Chevalier Carlo Barsotti, the Italian founder of *Il Progresso Italo-Americano* newspaper in New York City, addressed the crowd at the unveiling of the statue, which he presented to Washington in the name of Italian Americans. (LOC.)

Italian and American flags were hung over the Dante statue during the dedication ceremony. Head of Public Buildings and Grounds Clarence O. Sherrill's children Minnie Sherrill and Clarence Sherrill (standing in front of the statue) released the flags to reveal the memorial. Behind the statue, signal flags spell "Dante." (LOC.)

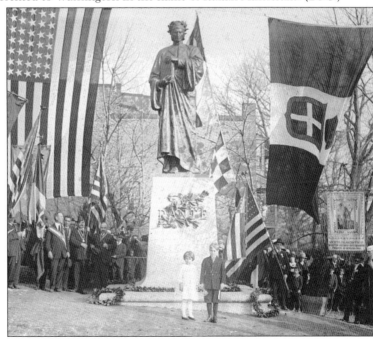

Col. Clarence O. Sherrill (1876–1959) was in charge of Public Buildings and Grounds from 1921 until 1925. He then became director of the newly formed Public Buildings and Public Parks of the National Capital from 1925 until 1926. In this role, he influenced the development, construction, and maintenance of public buildings and parks in the District of Columbia. He is pictured here seated in June 1922. (LOC.)

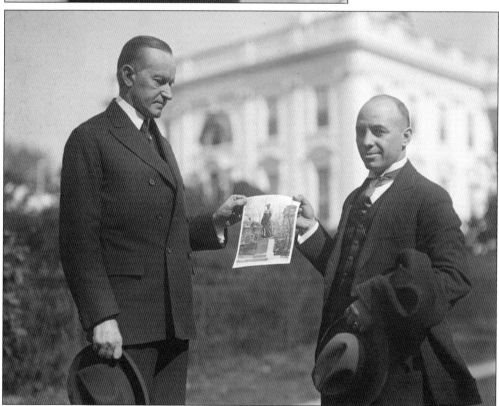

In 1924, Pres. Calvin Coolidge (left), Colonel Sherrill, and Salvatore M. Pino (right), representing *Il Progresso Italo-Americano*, an Italian newspaper in the United States, met at the White House. Pino requested the meeting to discuss the completion of the park. In 1922, the Dante statue was placed in the park; however, after two years, the lower portion was still unfinished, which detracted from the beauty and significance of the statue. (LOC.)

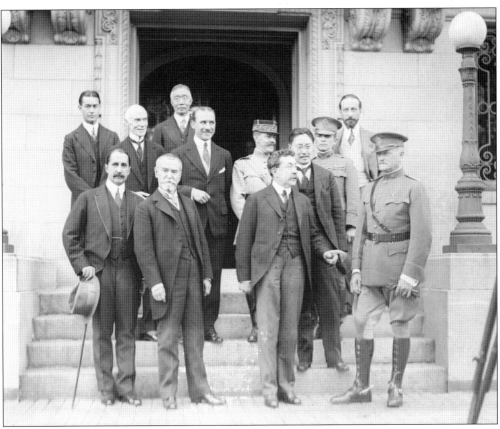

Jean Adrien Antoine Jules Jusserand (1855–1932) served as the French ambassador to the United States during World War I. Pictured here on the steps of the French Embassy, Jusserand (front, second from left) lived at 2460 Sixteenth Street during the first 10 years of park construction. He attended the Joan of Arc unveiling and the Dante memorial dedication. (LOC.)

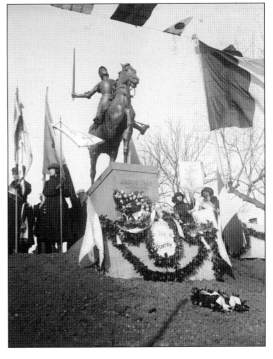

Dedicated on January 6, 1922, and placed in the center of the grand terrace of the upper park, the Joan of Arc statue was the second statue to be placed in the park. It was a gift to the women of the United States from the Society of French Women in Exile of New York and is the only equestrian statue of a woman in Washington, DC. (LOC.)

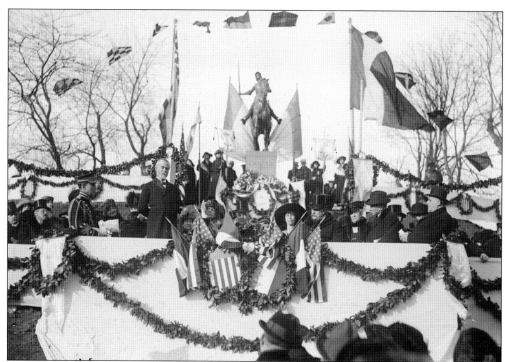

At the time of the Joan of Arc statue's dedication, the wall and cascades had not been built. Pres. Warren G. Harding and First Lady Florence Harding (above, center) attended the Joan of Arc ceremony, as did ambassador Jules Jusserand of France (center, standing). Speeches at the dedication ceremony were given by US Secretary of War John W. Weeks; Carlo Polifeme, president of the Society of French Women of New York, which gave the statue to the city; and Anne Rogers Minor, wife of George Maynard Minor and president of the National Society of the Daughters of the American Revolution, who accepted the statue on behalf of the women of the United States. Ambassador Jusserand also presented a medal from France to Polifeme for her work in getting the statue erected. Below, the area in the foreground was undeveloped at the time of the dedication. Looking north and upward toward the Joan of Arc statue during its dedication ceremony, the crowd is standing on the hill that is now the cascades of the lower park. (Both, LOC.)

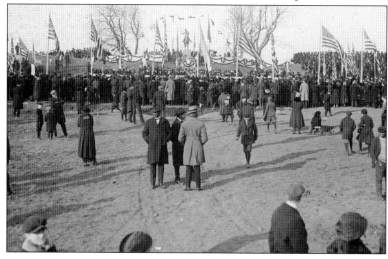

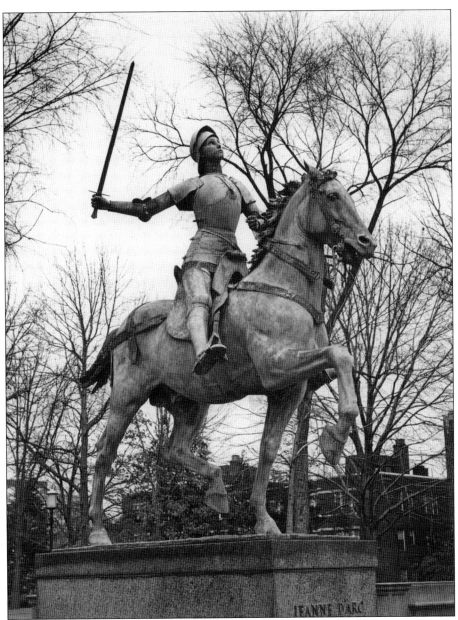

Portraying Joan of Arc in armor, looking toward heaven with her sword held high, the statue is a replica of the one Paul Dubois created in 1896 that stands in front of the Rheims Cathedral. The inscription on the front of the statue reads, "Jeanne d'Arc / 1412 – 1431 / Liberatrice /Aux Femmes d'Amerique / Les Femmes de France. The inscription on the back of the statue reads: Offert Par / Le Lyceum / Societe de Femmes de France / Le 6 Janvier, 1922." The placement of the Joan of Arc statue always frustrated Horace Peaslee, the park architect. Peaslee repeatedly appealed to the Commission of Fine Arts to move the statue. In one letter to the commission in 1939, Peaslee wrote that the Joan of Arc statue is "badly placed as seen from the lower garden, as well as in relation to the elements of the great terrace." Suggestions for moving the statue were proposed, including placement at the bottom of the west ascent or the north end of the mall, but these recommendations were never acted upon. (NPS.)

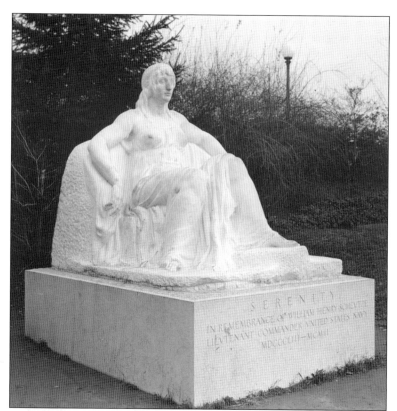

The Serenity memorial is dedicated to Navy lieutenant commander William Henry Schuetze. It was given to the United States by Charles Deering. Deering and Schuetze were classmates at the US Naval Academy in Annapolis, Maryland, and graduated in 1873. Deering had purchased the statue in Paris in 1900. When Schuetze died in 1902, Deering offered it as a gift to the United States in memory of Schuetze. (LOC.)

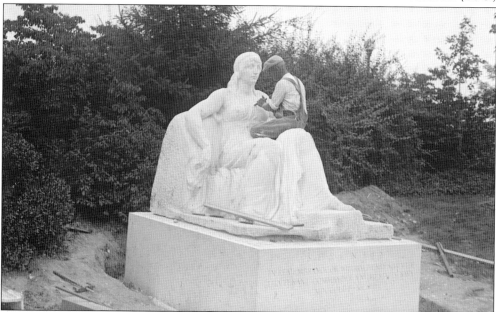

The memorial was accepted in 1924, and its placement in Meridian Hill Park began in 1925. The statue was placed in the park in July. There is an inscription on the front on the base of the statue reading, "Serenity / In Remembrance of William Henry Scheutze / Lieutenant Commander United States Navy / MDCCCLIII-MCMII. Note that Schuetze's name is misspelled. (LOC.)

Serenity is located in the northwest side of the park facing Sixteenth Street. The statue was sculpted by Jose Clara from a solid block of Carrara marble. The sculpture is five feet, six inches tall, and shows a woman wearing long, flowing classical robes that are tied at her waist. Her arms casually rest on rocks behind her, and her left foot rests on a broken sword. (LOC.)

Lt. Col. Ulysses S. Grant III (1881–1968) became director of Public Buildings and Public Parks in the national capital in January 1926, where he served until June 1933. In 1931, after Mary Foote Henderson died, a bill was passed in the House of Representatives to rename the park for her. Grant opposed this measure saying, "[Henderson's] interest in it has been largely in its beneficial effect on the value of her Sixteenth Street property." (LOC.)

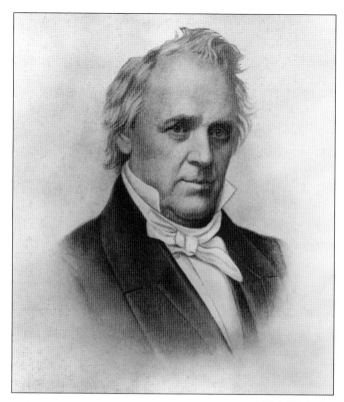

James Buchanan (1791–1861) served as the 15th president of the United States. His career included being a US representative and senator, minister to Russia, secretary of state under Pres. James K. Polk, and minister to Great Britain under Pres. Franklin Pierce. However, his presidency was marked by strife in the Kansas Territory and the Dred Scott Supreme Court case. Contentious debate led up to the acceptance of the Buchanan memorial gift. (LOC.)

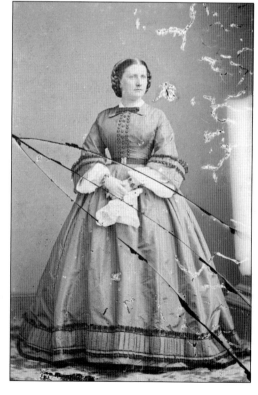

Harriet Lane Johnston (1830–1903) was President Buchanan's niece and acted as the First Lady during his presidency. Upon her death, she bequeathed $100,000 toward the construction of a memorial to her uncle. However, if Congress failed to accept the bequest within 15 years, the money would revert back to her estate. Congress made provision for a site and approved the memorial on June 27, 1918. (LOC.)

The dedication ceremony for the James Buchanan memorial was held on June 26, 1930, with Pres. Herbert Hoover addressing the crowd. Of Buchanan, President Hoover said, "His career was rich in achievements, deserving the gratitude of his country." The formal presentation of the statue was made by Roland S. Morris, former ambassador to Japan. The ceremony was not open to the public. During the dedication ceremony, the US Marine Band performed, and carrier pigeons were released. Stands were erected to provide seating for invited guests. The reflecting pool was filled for the first time in honor of the occasion. It was turned off immediately after the ceremony, as the water supply system had not been completed. (Right, LOC; below, NPS.)

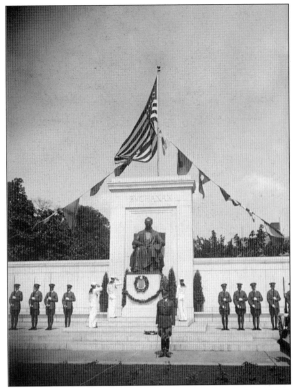

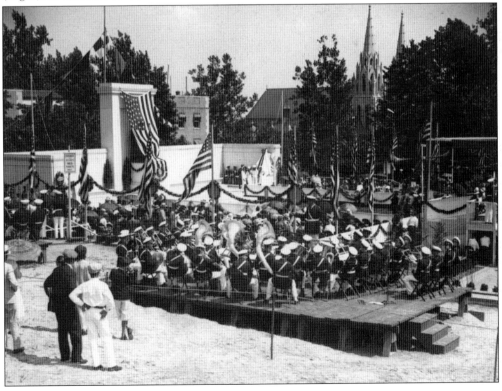

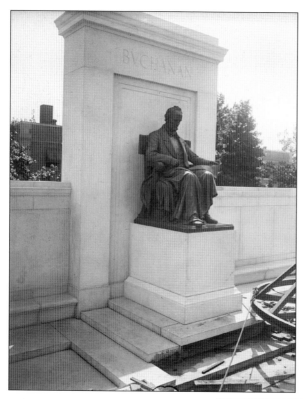

The Buchanan memorial was designed by sculptor Hans Schuler. The architects were William G. Beechers and J.B. Wyatt, both from Baltimore. The walls are made of white marble. The figure of James Buchanan is made of bronze and centered on the back wall of the memorial. Buchanan is shown seated in a chair and holding documents in his left hand. The seated figure is nine feet, six inches high and sits on a marble pedestal. Flanking the memorial are two allegorical figures of Law and Diplomacy carved in marble, along with the phrase, "The incorruptible statesman whose walk was upon the mountain ranges of the law." (Left, LOC; below, NPS.)

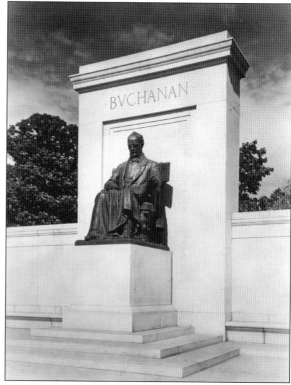

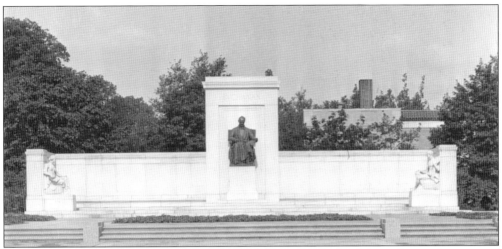

The memorial to Pres. James Buchanan sits in the southeast corner of the park near the corner of Fifteenth and W Streets and directly across the lower Sixteenth Street entrance. The memorial was funded by a bequest from Harriet Lane Johnston, Buchanan's niece. Congress accepted the funds for the memorial in June 1918. It took another 10 years to finish the memorial. (LOC.)

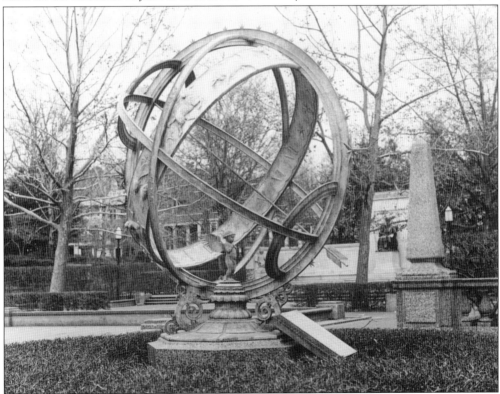

This photograph looks east through the armillary sphere toward the James Buchanan memorial. Armillary spheres consist of a framework of rings that represent lines of celestial longitude and latitude. The Noyes armillary had signs of the zodiac on the outside of the circle, and inside the circle stood a winged figure of a child. The armillary was cast in bronze. It was six feet, six inches high and five feet, eight inches in diameter. (LOC.)

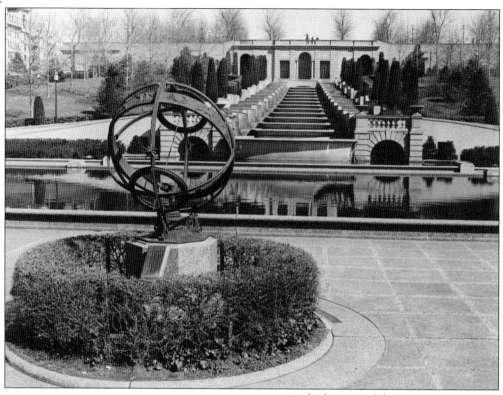

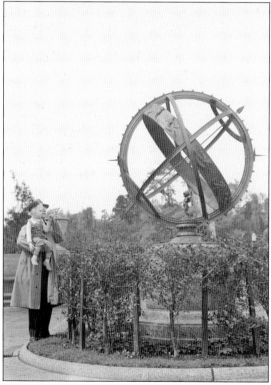

At the bottom of the cascades and at the park's southern exedra is the armillary sphere, placed and dedicated in 1931. Horace Peaslee thought the armillary sphere was the most appropriate sculpture in the park. Called the Noyes armillary because it was commissioned by Bertha Noyes in memory of her father and sister, the armillary was removed sometime after 1976 for cleaning and has since been missing. (LOC.)

The bronze sphere, 16 feet in circumference, was engraved with, "Given to the Federal City, MCMXXXVI, for Edith Noyes." The armillary was mounted on a granite pedestal three feet in height. Within the sphere were Roman numerals marking the hours of the day. In the center was a winged figure of a child greeting the sun. Adjustments were made by a Columbia University astronomer so that the dial was accurate. (Courtesy of the Commission of Fine Arts.)

Three

FROM PLANNING TO A PARK
1910–1936

The park design took advantage of the view, the hillside, and the natural plateau to create two distinct park areas. The original design of the park was ambitious, and it was estimated that it would take 12 years and cost $300,000.

The upper park that took advantage of the plain stretching from approximately Belmont Street to Euclid Street was to include a parking area, formal and informal walkways, and a concert pavilion. The grand terrace was designed to include the concert area and provide a view of the landscape and scenery to the south. The lower park was designed to take advantage of the hillside and incorporated many aspects of Italianate park design into the proposal. The main focus of the lower park is the 13-basin cascade and reflecting pool.

Development of the park began in 1915. One of the first elements to be completed was the Sixteenth Street retaining wall. In 1915, John Earley was contracted to begin construction of the wall. Originally, the design called for a concrete wall with a stucco finish. This proved to be dull and unacceptable. Earley suggested that the wall could be constructed of concrete with an aggregate finish. This process required adding aggregate to the concrete while it was finishing. It was concluded that the process was too laborious and, most likely, would not withstand long-term exposure to the weather. These experiments lead Earley to add pebbles to the concrete mix, and the results were exceptional. The process, which Earley referred to as "architectural concrete," was used throughout the park for the walls, balustrades, staircases, benches, and basins. The wall along Sixteenth Street was completed by April 1916.

The work continued until, in 1936, the park was officially opened on September 26. It had taken more than 26 years and over $1.5 million.

This image from about 1919 shows the outline of the park after the land was cleared of buildings. Boundary Castle, a large brownstone mansion, is at right center. Farther up Sixteenth Street to the left is the Meridian Mansion apartment building, now the Envoy, at 2400 Sixteenth Street, built between 1916 and 1918. It was designed by architect A.H. Sonnemann and considered one of the city's finest apartment hotels when it opened on February 10, 1919. Also shown is the French Embassy at 2460 Sixteenth Street and the "Pink Palace" at the corner of Sixteenth and Euclid Streets. Visible in the park outline is the first section of the west wall of the park. (NPS.)

On June 25, 1910, the land for the park was designated for acquisition, and permission was given to acquire or condemn property in order to secure the land. This photograph, looking north, shows the area that would become the upper mall of the park. The houses shown are within the bounds of the park along Fifteenth and Euclid Streets in the park's northeastern corner. The park purchase was completed by September 1912. (LOC.)

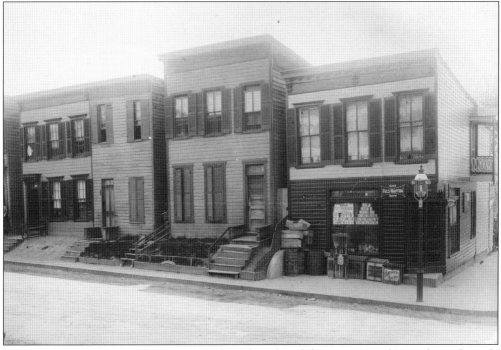

This photograph, taken at the corner of Fifteenth and Euclid Streets around 1910, shows the style of housing typical in the area. After the land was purchased, the tenants were required to pay rent to the chief of engineer's office. Beginning in November 1912, authority was given for the removal of the buildings on the park, and the houses were torn down by January 1913. (Courtesy of the Commission of Fine Arts.)

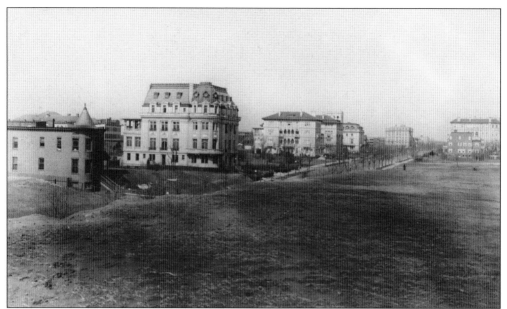

This photograph from about 1920 shows Sixteenth Street after it was extended north from Florida Avenue. It shows the undeveloped, upper-west side of the park, with views of the French Embassy (center left), at the corner of Sixteenth Street and Kalorama Road. Also shown is the Pink Palace (center), at the corner of Euclid Street. Both were built by Mary Foote Henderson and designed by architect George Totten. (NPS.)

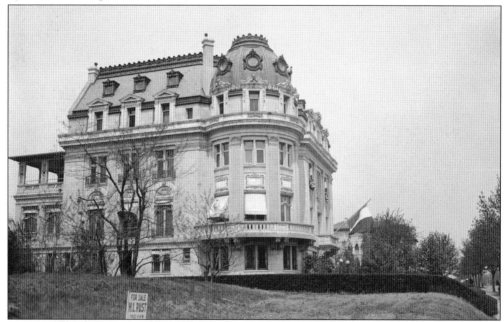

Pictured in 1917, the French Embassy was one of the first projects in the Meridian Hill neighborhood, completed by Mary Foote Henderson and George Oakley Totten Jr. The house is located at 2460 Sixteenth Street on the west side of the park. It was completed in 1908, and the first tenant of the building was ambassador Jules Jusserand. Behind the embassy is the Pink Palace, located at 2600 Sixteenth Street. (LOC.)

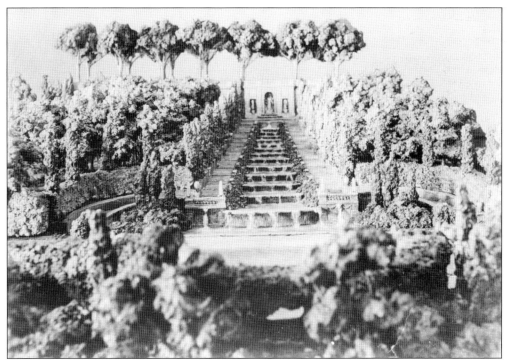

In June 1913, funds were appropriated for further development of the park plans, including clay models of the entire park. The model of the cascades seen above shows the dense planting plan of trees and shrubs for the lower hillside gardens. The idea, based on Italian park designs, was to create groves for shade and privacy. The dense plantings were not completed. The model for the exedra, pictured below, included a center focal point. The designers wanted the exedra to be impressive because it was the terminal point for the lower park's dramatic water feature. Eventually, the armillary would become the centerpiece of the exedra. (Both, LOC.)

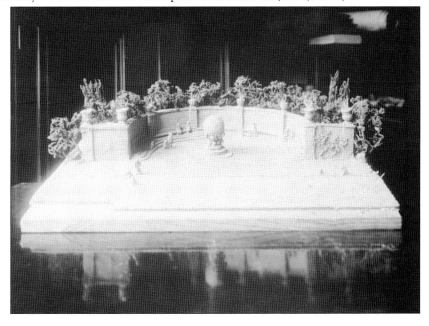

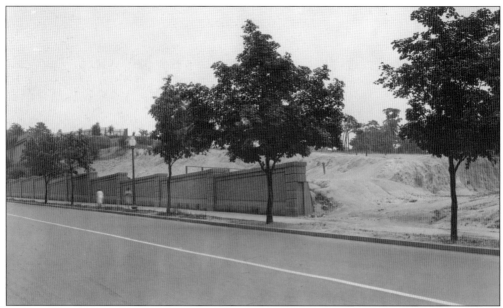

John Joseph Earley began working on the Sixteenth Street retaining walls in 1915 and completed them in 1916. The walls were the first completed construction project of the park and were designed to preserve the stability of the hill and are 40 feet above the street. The architectural concrete used for the walls had to be tested, perfected, and then approved before construction could continue. The walls were poured in place in 25-foot sections and in a multi-staged process to attain the different finishes when complete, as noticeable in the image below. The distribution of the aggregate becomes more evenly graded in the later sections of the wall. (Above, courtesy of the Commission of Fine Arts; below, LOC.)

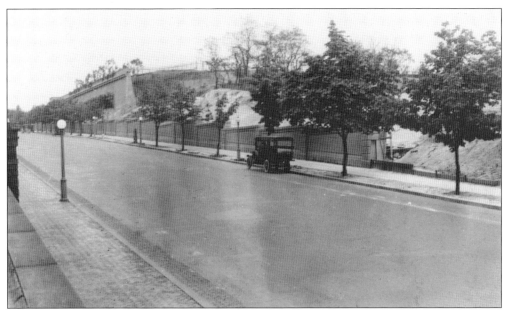

Meridian Hill Park is a walled park. There are two walls: a high wall and a low wall, placed along Sixteenth Street for stability of the upper park and great terrace. Instead of creating a single retaining wall for the hillside of the upper park, approximately 60 feet high, two retaining walls were installed. Shown above is a view of both the high and low retaining walls. The high wall runs from the grand Sixteenth Street entrance to the great terrace. The low wall runs along the sidewalk from Euclid Street to W Street. The stepped wall has four entrances, and reaches heights of 40 feet. The fencing along the low wall, pictured at center below, is where the stairway entrance to the great terrace was designed to be. That entrance was not constructed. (Above, courtesy of the Commission of Fine Arts, below, NPS.)

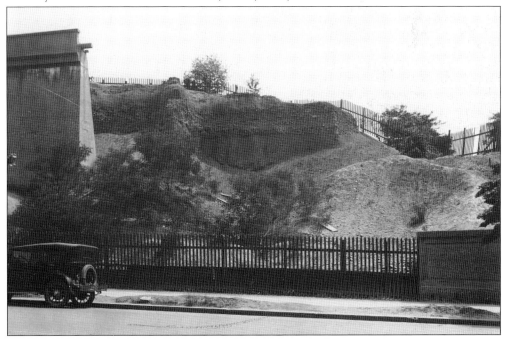

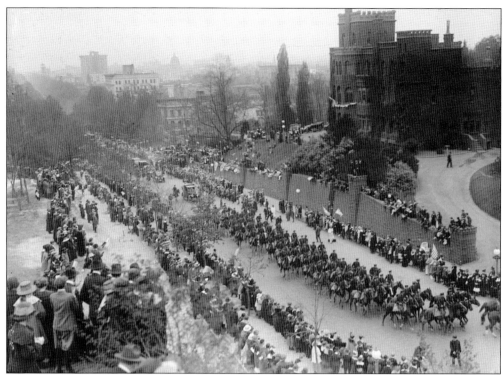

On April 25, 1917, Rene Viviani, French vice premier and minister of justice, and Gen. Joseph Joffre, marshal of France, visited Washington, DC, to meet with President Wilson and members of his cabinet for a formal war council regarding World War I. The French mission landed at the Navy yard and was escorted through the city by mounted police and the 2nd US Cavalry. They went to former French ambassador Henry White's house at 1624 Crescent Place, across from Meridian Hill Park, which he had offered to the mission for their stay. The crowd pictured above in the foreground is standing on the Sixteenth Street hillside that would become part of the lower park. The high and low retaining walls would not be completed until 1918. Boundary Castle, the home of John and Mary Foote Henderson, is visible in the background. (Both, LOC.)

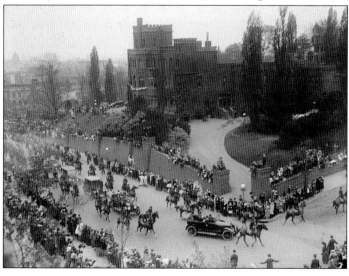

Henry White's house at 1624 Crescent Place was designed by John Russell Pope and completed in 1912. The house is situated between Belmont Road and Crescent Place and overlooked Boundary Castle. John Russell Pope also designed the Meridian House that was built for ambassador Irwin Boyle Laughlin in 1919 and sits next door to the White mansion. Henry White (1850–1927) was born in Baltimore and educated in France. In 1905, he was appointed ambassador to Italy, and in 1906, he was promoted to ambassador to France, where he served until 1909. In 1917, he hosted the French mission at his house. Then, in 1918, he was invited by President Wilson to serve as one of the five American Peace Commission members to work on a peace treaty with Germany, as seen below. Henry White is second from left, and President Wilson is at center. (Both, LOC.)

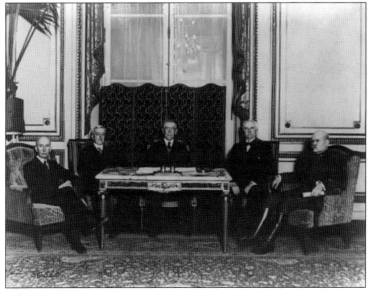

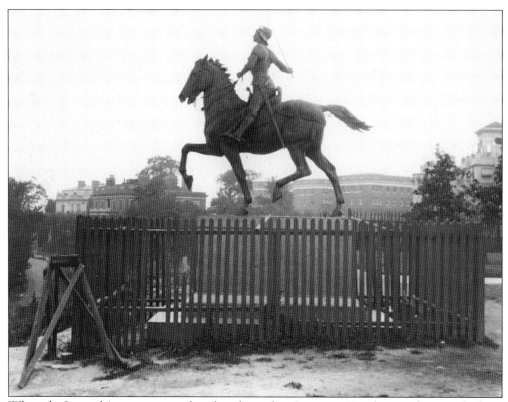

When the Joan of Arc statue was placed in the park in January 1922, the grand terrace had not yet been constructed. The concrete walkways from Euclid Street to the grand terrace would be completed in 1923. The houses behind the statue, seen above, are the White-Meyer House (far left) and Meridian House (second from left) on Crescent Place, both designed by John Russel Pope. The building at far right is the Meridian Mansion apartments. Crescent Place cooperative (center) was completed in 1926. The temporary building on the grounds of the park was located on the east side of the statue of Joan of Arc, as seen below. The houses in the background are located on Fifteenth and Belmont Streets. (Both, NPS.)

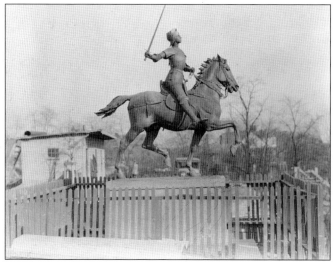

The image above of the lower park looking up the hillside is from about 1929 and shows the finished reflecting pool of the lower park. In the foreground is the semicircle that will be the placement for the armillary sphere. Construction of the lower park began in 1928 with a contract for the reflecting pool, the plaza and walkways, the exedra wall seats, and the water supply and drainage system being completed by the Charles A. Tompkins Company in 1929. The hillside between the Joan of Arc statue and the reflecting pool was excavated to create the cascades, with 15,000 cubic yards of earth removed in 1928. Also visible at left are a construction crane and construction materials used for additional wall underpinnings on the Sixteenth Street side of the upper park. (Both, NPS.)

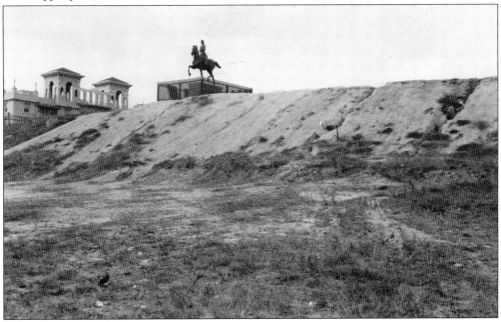

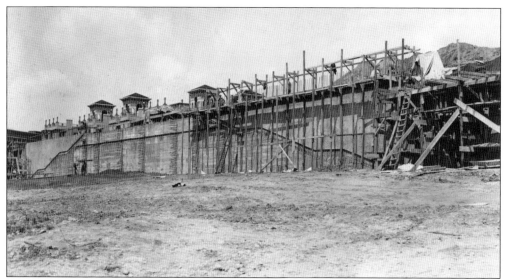

The retaining wall for the grand terrace is 20 feet tall and also forms the cascades of the lower park. The position of the grand terrace takes advantage of the crest of the highest area in the park. The grand terrace is 60 feet wide and spans the entire park from Sixteenth Street to Fifteenth Street. This image from 1930 shows the framework construction of the grand terrace wall. (NPS.)

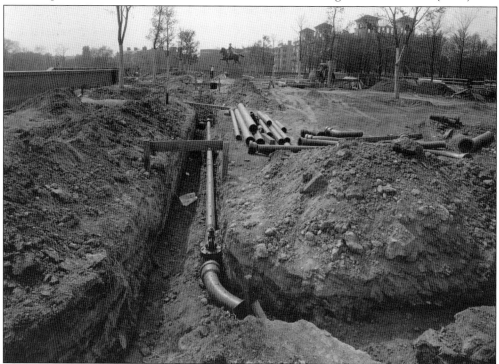

Piping and drainage was necessary throughout the park. The system included gutters, catch basins, and trench drains, as seen here. The gutters were placed along the retaining walls and walkways. The trench drains are located on the ascents and entrances with stairs. The drains are covered with metal strips. This view, looking west across the grand terrace, shows the placement of the pipe trench in April 1936. (NPS.)

The work on the lower park had slowed down by 1927 due to lack of appropriations. But in 1928, the Senate approved $100,000 for the continued construction of Meridian Hill Park. The architectural elements were constructed before the plantings were placed in the lower park. The image above from about 1929 shows the uncompleted hillside of the lower park with the partially constructed west ascent stairway. The image below from August 1931 shows the completed grand terrace. The beginning of the cascades can be seen in the middle of the grand terrace. The plantings in the foreground are from the area in front of the Buchanan Memorial that had been placed in the park in 1930. On the left side of the grand terrace is the Meridian Mansion (now the Envoy) apartment building. (Above, courtesy of the Commission of Fine Arts; below, NPS.)

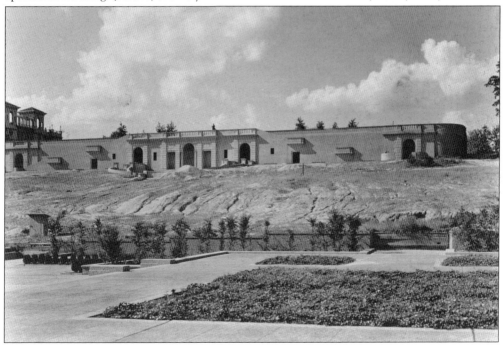

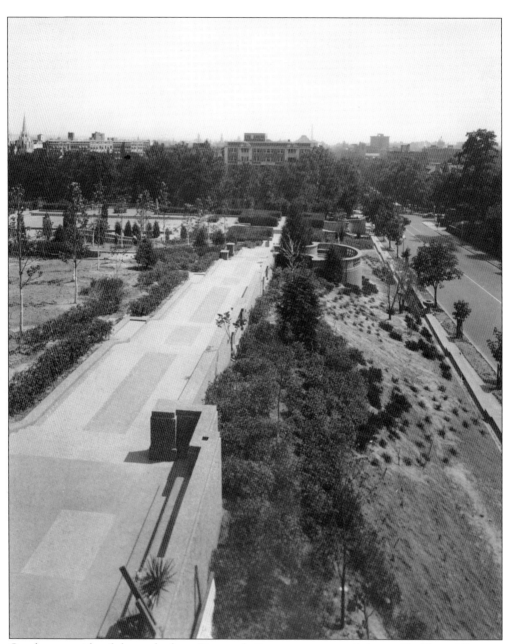

On the west side of the park along Sixteenth Street are two retaining walls. Two walls were constructed to preserve the stability of the hill, which rises 40 feet above the grade of the street. Planting plans for the park included specific proposals for the hillside. This photograph from July 1936 shows the plantings along Sixteenth Street between the two retaining walls. Also shown are the completed west ascent stairs, the west side overlook in the lower park, and the entrance to the lower park. Visible along the Sixteenth Street wall is a planting urn. Horace Peaslee designed the planting urns to be placed at certain points along the wall to be planted with ivy so that it would soften the view. The apartment building in the background is the Hadleigh Apartments (Camden Roosevelt Apartments) that were constructed in 1919 and obstruct the view south. In the far background is the Washington Monument. (NPS.)

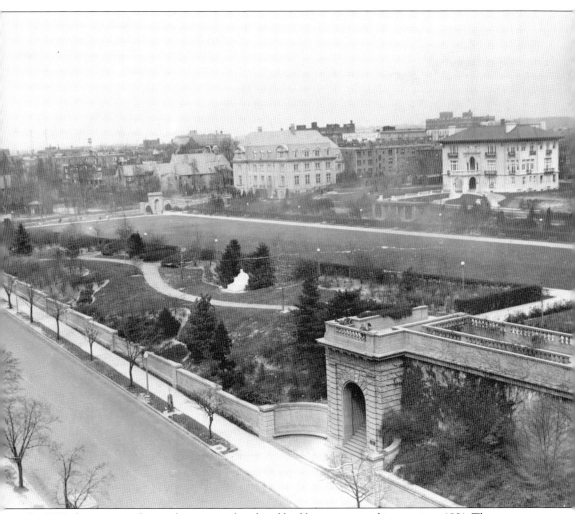

By 1927, the upper park was almost completed and had been open and in use since 1921. The main entrance from Sixteenth Street to the upper park, shown here in the foreground, was completed in 1918. Visible on the right side of the entrance is the meridian plaque dedicated by the Daughters of the American Revolution in 1923. The entrance on Sixteenth Street is opposite Crescent Place, and the covered stairway leads to the upper park at the walkway lined with linden trees. In the upper park, the entrance is designed as an overlook. The Serenity memorial is at center, along the winding side path. In the background is the Embassy of Hungary (now the Josephine Butler Parks Center), at 2437 Fifteenth Street. Completed in 1927, the house was designed by architect George Oakley Totten Jr. for Mary Foote Henderson. Also shown is the current Embassy of Ecuador at 2535 Fifteenth Street, also designed by Totten for Mary Foote Henderson. (Reprinted with permission of the DC Public Library, Star collection, © Washington Post.)

The mall of the upper park, from Euclid Street to the great terrace, was completed by 1921, and officially opened to the public in 1923. Work included landfill and excavation as well as installing drains and laying out the walks. The ground was plowed, graded, fertilized, and sown with grass seed in 1920. The benches shown are temporary, and were not part of the completed park. The large building in the background at left is the French Embassy. The image below shows the completed informal path of the west side of the upper park. (Both, NPS.)

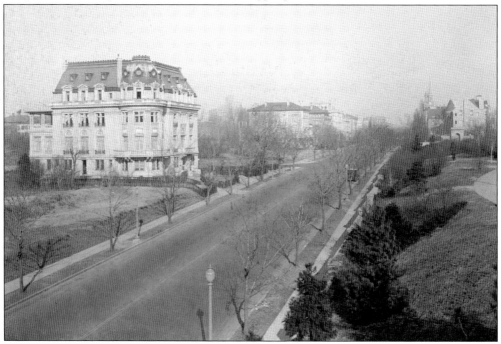

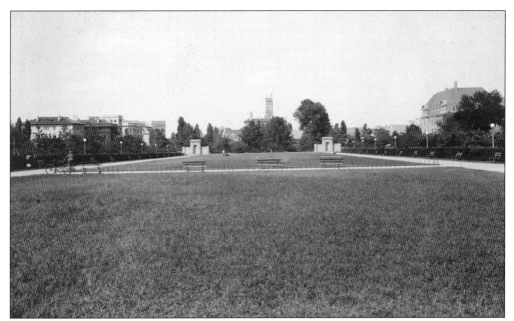

This view shows the upper mall stretching north toward Euclid Street. In the 1920s, the French bought land on Euclid Street between Sixteenth and Fifteenth Streets in order to build a new embassy there. The design of the park actually accommodated this possibility. Between the two decorative niches, the fence is made of wide-columned iron that provides excellent views of the park. The French never built on the property. (Courtesy of the Commission of Fine Arts.)

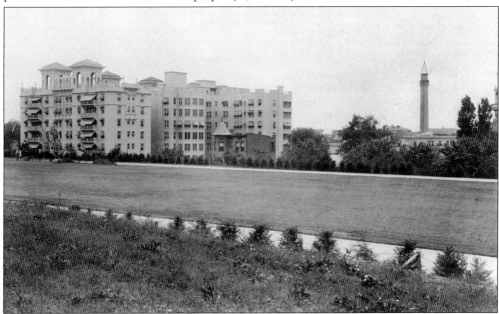

The imposing structure on the west side of the park is the Meridian Mansions at 2400 Sixteenth Street. Now the Envoy, the Meridian Mansions was built as a luxury apartment and hotel building and opened in 1918. The building, designed by Alexander H. Sonnemann, is seven stories and was originally topped with rooftop pavilions. The pavilions were removed in the 1970s after a renovation. (Courtesy of the Commission of Fine Arts.)

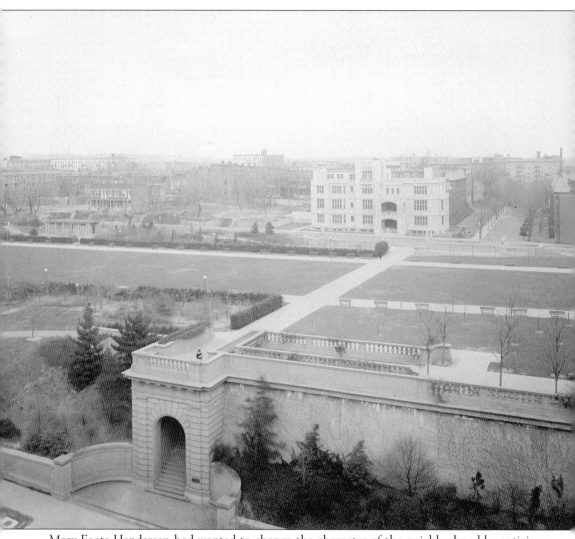

Mary Foote Henderson had wanted to change the character of the neighborhood by enticing foreign embassies to the area. She purchased land and then worked with George Oakley Totten Jr. on the design of the houses. Henderson would then offer the mansions for rent or purchase as an embassy. Shown here at center is 2401 Fifteenth Street at the corner of Chapin Street, which was designed by Totten. The mansion was completed in 1924, but stood vacant until 1927, when it was rented to the Egyptian government for their legation. Also shown in the foreground is the upper wall of the Sixteenth Street entrance. Topped with a balustrade, the wall also incorporates planting wells for ivy and wisteria. The planting plan called for extensive use of vines to add color and soften the entrance, although the vines have not been maintained. Also seen in the center of the upper mall is the park lodge. The lodge originally had two rooms separated by a breezeway. The lodge now provides restrooms and a small office. (Courtesy of the Commission of Fine Arts.)

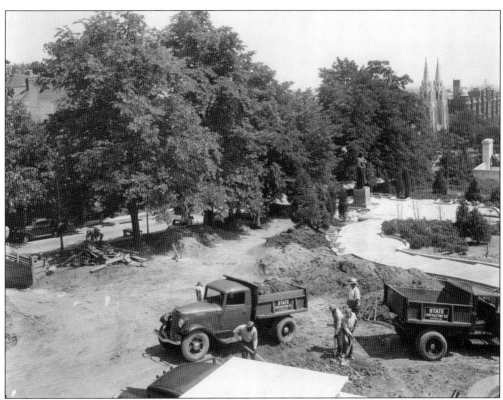

The hillside of the lower park was divided into four boscos, or groves, along the main north-south axis and the middle east-west axis. By 1936, the planting plan had been simplified and the resulting hillside was much more open. Here, workmen are completing the plantings near the Dante statue. In the background are the Buchanan memorial and the spires of St. Augustine. (NPS.)

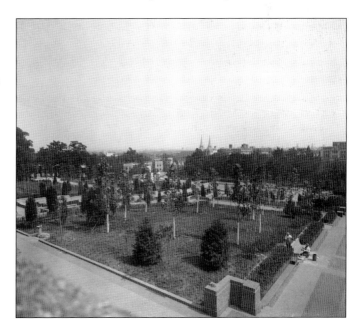

This photograph taken from the western corner of the grand terrace shows a view of the lower park looking toward the cascades. Also visible is one of several styles of benches that would be used throughout the park. The benches on the west ascent have curved concrete legs with wood-slat seats and backrests. The plantings on the hillside include Virginia pine, eastern redbud, flowering dogwood, and shadblow serviceberry. (NPS.)

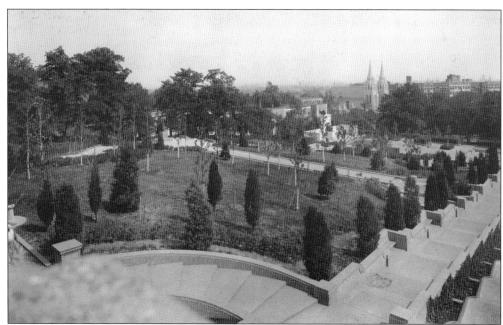

The original plan for the lower park area was to have thickly planted areas that would form boscos and be reminiscent of an Italian garden. This was in keeping with the entire concept of the lower park with the cascades as the dominant focal point that also included paths bordered by shrubs and hedges. By 1936, the hedged walkways were planted, but the hillside plantings were not as dense as originally planned. The view above, looking southeast from the center of the grand terrace, includes the spires of St. Augustine Catholic Church. The view below from the grand terrace facing southwest shows the newly planted area in 1936 and also includes a view of Boundary Castle, the home of Mary Foote Henderson. The hillside gardens were planted with sycamores, dogwoods, and redbuds, and American holly was planted along the cascades. (Both, NPS.)

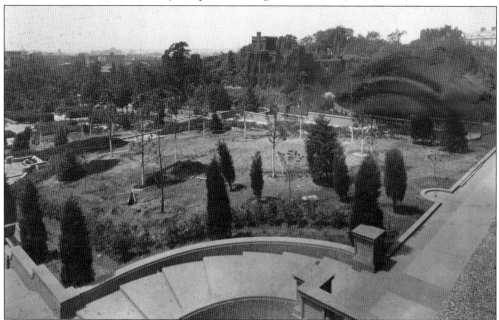

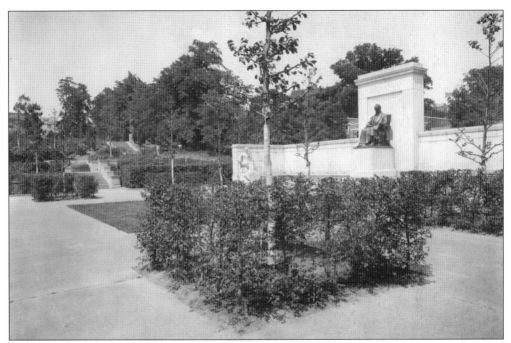

The Buchanan memorial was added to the park plans as early as 1914, but the plantings were not completed until 1936. The area includes grass in front of the memorial, with hornbeam and sycamores or plane trees in the boxes. In 1996, the trees were replaced with Japanese zelkova, and the under planting was changed to grass. Also shown is the east ascent that runs between the grand terrace and the lower park. (NPS.)

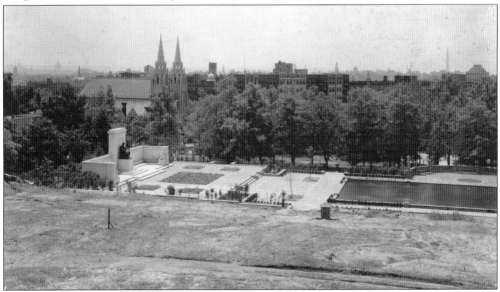

The lower plaza was created to be a formal space, with a clearly defined, open plaza. The plantings reinforce this concept, creating walls with hedges of American hornbeam, and defining spaces with large shade trees. The reflecting pool has four large elm trees at each corner, later replaced with sycamores. The space in front of the Buchanan memorial is also defined by four large trees. (Courtesy of the Commission of Fine Arts.)

The view above looking south of the neighborhood before development shows the area in the southwest that would become the lower park. Although most of the hillside was cleared and excavated to develop the walls, walkways, and the cascades, some of the trees closer to W Street were kept as part of the planting plan. Shown below is the same area, though looking north, after development. By 1932, the water features, the cascade construction, and the reflecting pool were completed in the lower park. From 1932 until the opening of the park in 1936, much of the work focused on plantings. Between 1928 and 1936, the lower park was completed. The water features, including the piping and recirculation system, were built between 1928 and 1930. (Both, courtesy of the Commission of Fine Arts.)

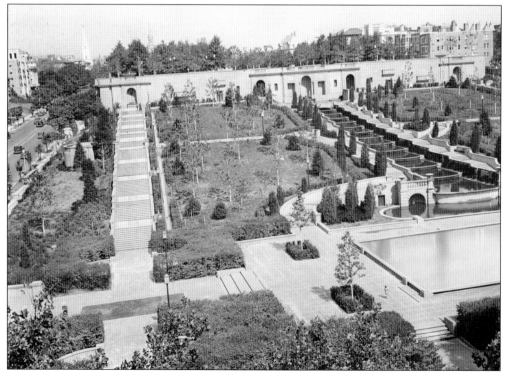

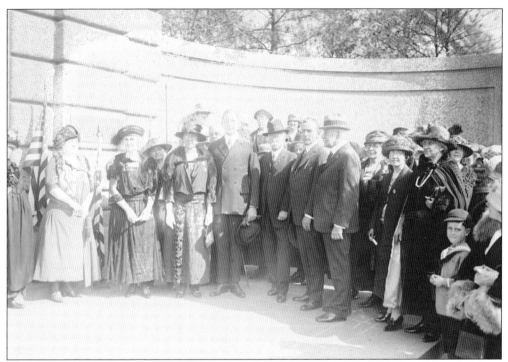

On May 2, 1923, a ceremony was held at the Sixteenth Street entrance to unveil a plaque memorializing the meridian stone. The meridian stone was a privately placed stone located in the center of what is now Sixteenth Street marking the meridian. The plaque is 18 by 24 inches and was donated and dedicated by the Daughters of the American Revolution. (LOC.)

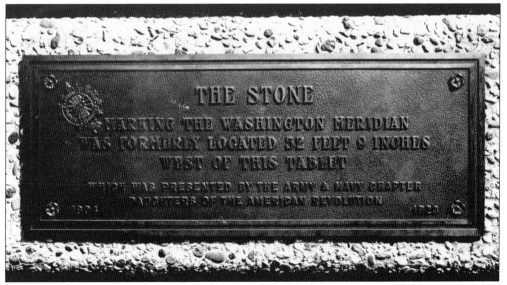

The meridian plaque is affixed to the wall to the right side of the Sixteenth Street entrance, and adhered with rose pins. The inscription reads: "The Stone / Marking the Washington Meridian / Was Formerly Located 52 Feet 9 Inches / West Of This Tablet / Which Was Presented By The Army & Navy Chapter / Daughters Of The American Revolution / 1804–1923." (Courtesy of the Commission of Fine Arts.)

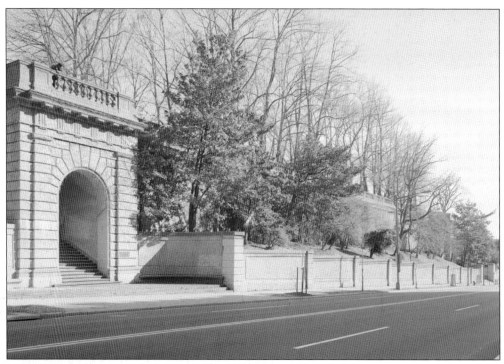

Designed as one of two grand entrances to the upper mall of the park, this entrance was the only grand entrance to be completed. The tall, arched opening encloses a partially covered stairway with a landing. The landing, lit with natural light and a lamp, also includes molded concrete benches. On the right side of the entrance is the Meridian plaque, placed there in 1923 by the Daughters of the American Revolution. (LOC.)

The arched entranceway of the main Sixteenth Street access leads to an open stairway and then to the linden allee. From the street, the stairs lead through a fountain area with a bench and then to an open stairway. Design details in the entranceway include a hanging lamp, a water niche with a hooded, female face in relief, and molded concrete benches. (LOC.)

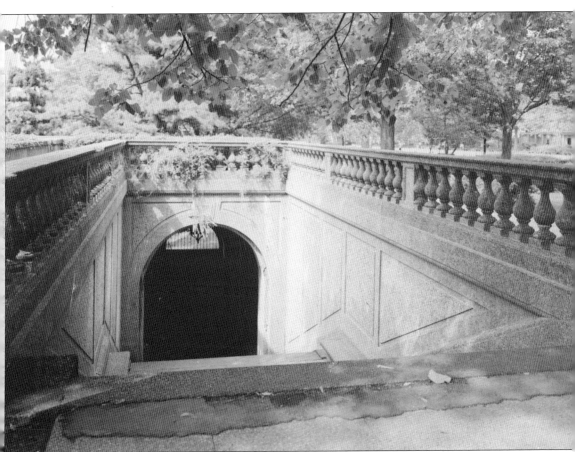

Completed in 1918, this became the primary entrance from Sixteenth Street to the upper park mall. The Sixteenth Street retaining wall forms part of the front wall, and the high retaining wall forms part of the back. According to John Earley in his article "Some Problems in Devising a new Finish for Concrete," "The second operation at Meridian Hill Park consisted of a balustrade 300 ft. long located on the upper level of the park, and an arched entrance with a flight of steps connecting the upper level and the street. . . . The technical progress made in the execution of this work and the great improvement shown in the results [was] largely due to careful study . . . of the first operation." The entrance was a classical arch flanked by pilasters and surmounted by a compete entablature. In order to create the arch and the balustrade, Earley went through many different molds, different concrete formulas, and different methods for finishing the casts until the technique was perfected. Part of the original planting plan was to add vines along the balustrade to add color and soften the design. (LOC.)

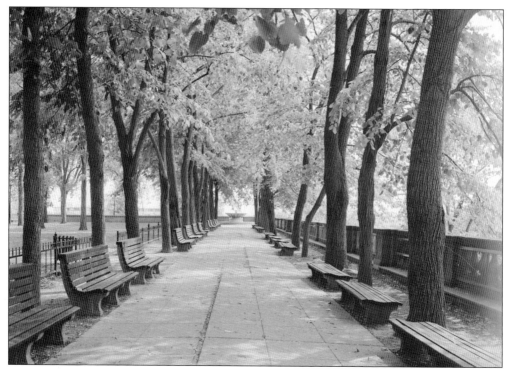

The linden allee is in the upper park and connects the main Sixteenth Street entrance with the great terrace at a bowl fountain. The original linden trees were planted sometime around 1925 and conceptualized to be pleached, a technique that interweaves branches to form, in this case, an archway. This work-intensive plan was never carried out. The walk seen above is lined with benches and fencing, and the mature trees create a sense of intimacy. In 1982, the mature linden trees appeared to be affecting the stability of the Sixteenth Street retaining wall. During restoration work to shore up the retaining wall, the lindens were removed, and young trees were planted. This process also removed the fencing and benches, which have not been replaced. (LOC.)

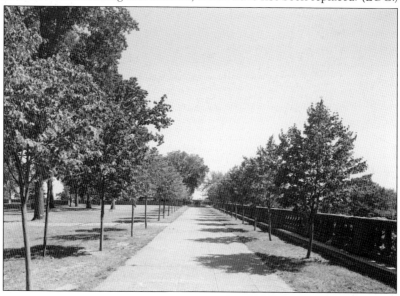

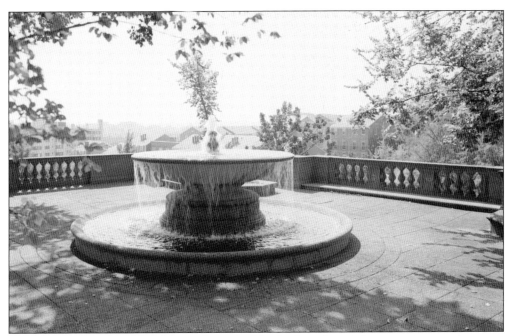

Shown here is the bowl fountain at the end of the linden allee. A fountain sits at each corner of the great terrace and terminates the major east-west axis of the upper park. Each fountain is made from concrete aggregate in the shape of a large urn with a single center jet. Views from this corner, looking south, include the Washington House (left), and Beekman Place townhouses (right). (LOC.)

The original design of the upper park included carriage drives and parking areas and a concert pavilion. The area was simplified to be a grassed mall with two formal promenades that converge at the great terrace. The mall is lined with white oaks with hedges of hemlock that separate the formal walkways from two informal, winding pathways. The building on the left side of the walkway is the park lodge. (LOC.)

The construction of the upper mall area was completed in 1921 and was used by those in the neighborhood since that time, but the mall was not officially opened to the public until 1923. By that time, the trees and bushes had been planted and the benches, trash cans, and water fountains had been installed. A lodge was built near the Fifteenth Street entrance to the park that provided an office for park personnel and public restrooms. Benches line both sides of the formal walkway. This view also shows the mature oaks that create shade and define the mall. The Meridian Hill Hotel for Women, completed in 1942 at 2601 Sixteenth Street, is seen in the background below. (Above, LOC, below, NPS.)

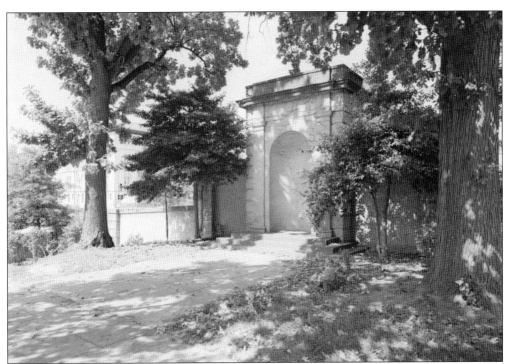

Located at the end of the two mall promenades are ornamental concrete wall niches. The niches are focal points on the northern wall that runs between Sixteenth and Fifteenth Streets along Euclid Street. In between the two niches is a wrought iron fence that sits on a low concrete foundation and is topped with armillaries on hexagonal supports and arrowhead finials, seen at right. The use of iron fencing that allows views into and out of the park is unique to this side of the park. A new French Embassy was going to be constructed on Euclid Street overlooking the northern end of the park, and the fencing was chosen in order to allow views of the park from the embassy. It was never constructed. (Both, LOC.)

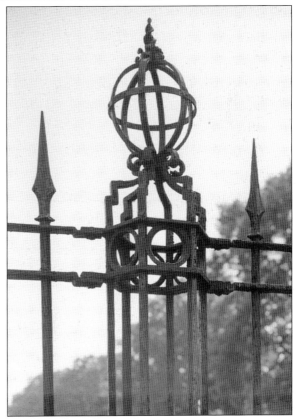

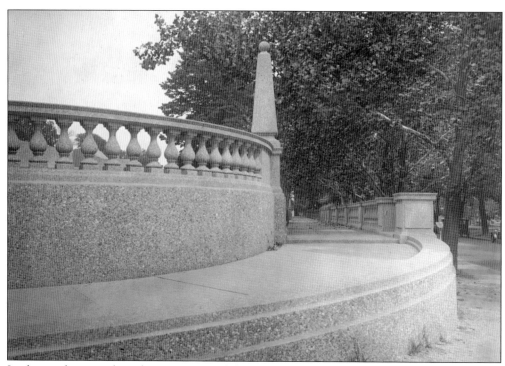

In the southeast and southwest corners of the park are two walled entrances providing access to the lower park from W Street. The entrances are accessible from the street and the W Street walkway. In the image of the west side entrance above, the walled entrances are curved and topped with a balustrade and decorated with obelisks. In the photograph below, the entrance leads to a bench area made of molded concrete that curved into the entrance, creating an open circle. The walkway continues past the seating area and into the lower park plaza. Visible in the background is the Buchanan memorial. (Above, courtesy of the Commission of Fine Arts; below, LOC.)

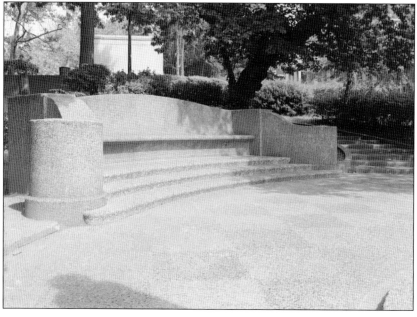

At right, facing west along W Street toward Sixteenth Street, is a raised walkway about four feet above street level, with a railing that alternates balustrade with solid walls. The walkway joins the two corner entrances of the lower park. Along the walkway are long stretches of wood slat benches, and decorative urns planted with yucca to add color and soften the wall view. Two entrances lead from the walkway to the reflecting pool. The W Street wall was supposed to be solid with tall hedges, but it was thought that that would be offensive to people walking on W Street. The compromise was to eliminate much of the plantings while keeping the wall the same height and use an open balustrade for visual access. Corner entryways were added, and benches were designed for them. (Right, LOC; below, NPS.)

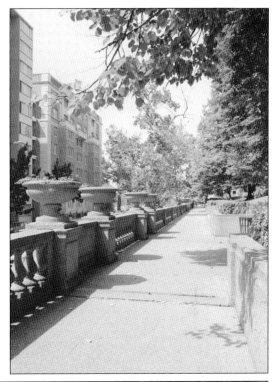

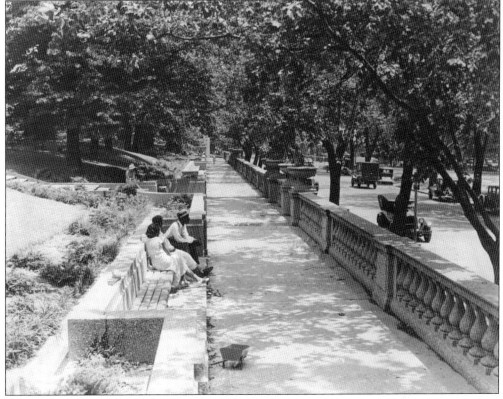

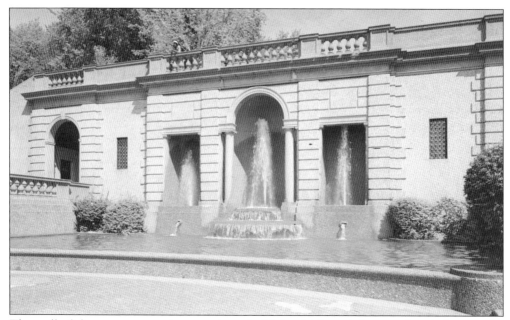

The wall of the great terrace is approximately 20 feet high and decorated with three niche fountains. The central colonnaded arch is flanked by two smaller square recessed niches. The fountains flow into a large basin at the foot of the wall and provide the source of water for the cascades below. The central fountains are flanked by two arched entryways that give access to the restrooms and the National Park Service maintenance space. (LOC.)

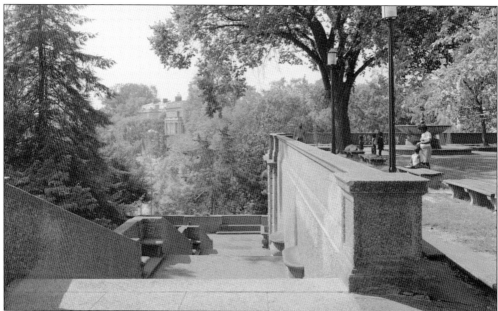

Access from the great terrace to the lower park is reached from two identical staircases that are set against the great terrace wall. The 42 stairs are broken up by two landings with small seating nooks. This view looking west shows the west side of the great terrace and the great bowl fountain. The houses in the background are the White-Myers House (left) and the Meridian House (right), both designed by John Russell Pope. (LOC.)

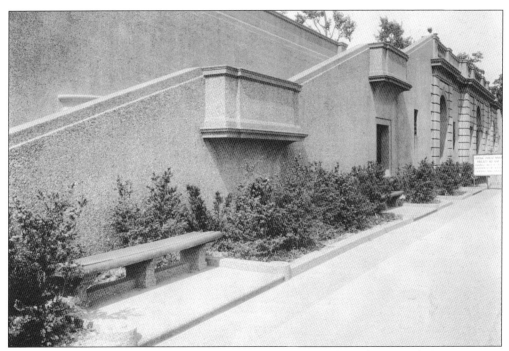

The great terrace wall divides the upper park from the lower park. In the original plans, access to the upper and lower parks was from the street level only. The grand staircases were added in later plans. The pair of staircases on the west (seen here) and east sides have seating niches. Underneath the stairs is the plumbing system for the water features. Horace Peaslee, the park architect, took care to design almost all the elements in the park. The water fountain seen below, located along the walkway (center), was designed by Peaslee. His design included a shell-shaped basin with a fluted shaft and a base with projections that formed steps so that children could use the fountain. These water fountains have been replaced with standard National Park Service water fountains. (Above, NPS, below, courtesy of the Commission of Fine Arts.)

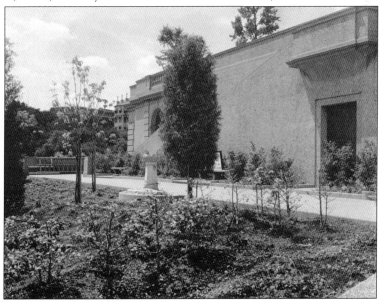

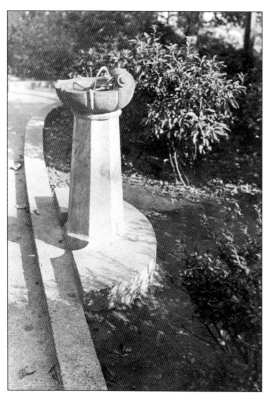

The water fountains had been designed specifically for Meridian Hill Park by Horace Peaslee and were well-received by the commission. In a 1939 memorandum of agreements laid out by the Commission of Fine Arts and Horace Peaslee, it was agreed that "the shell-type drinking fountains designed for Meridian Hill were to be recommended for use in other parks in lieu of less decorative forms." (NPS.)

From 1930 until 1932, the cascades were completed. The 13-basin cascades vary slightly in size, with the bowls getting larger closer to the reflecting pool, which gives the perspective of evenly sized basins when viewed from above. Visible in this image is the west ascent. Designed as a formal walkway, it is straight and lined with benches. Halfway up the west ascent is the terminal overlook for the east-west access across the cascades. (Reprinted with permission of the DC Public Library, Star collection, © Washington Post.)

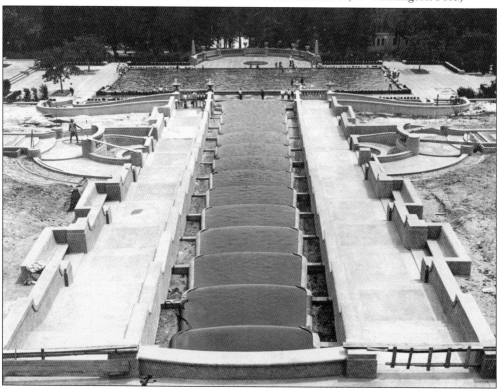

The west ascent, from the lower park to the great terrace, creates grandeur and formality on a minor park axis. The ascent is composed of 12 steps punctuated by five landings with intermittently placed benches in nooks framed by plantings. The stepped wall also has generous coping to allow for seating. The steps lead from the lower garden to a fountain niche in the great terrace wall. (LOC.)

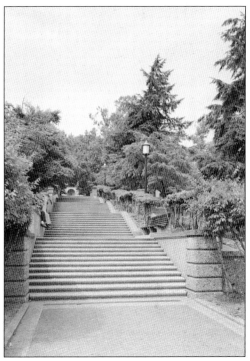

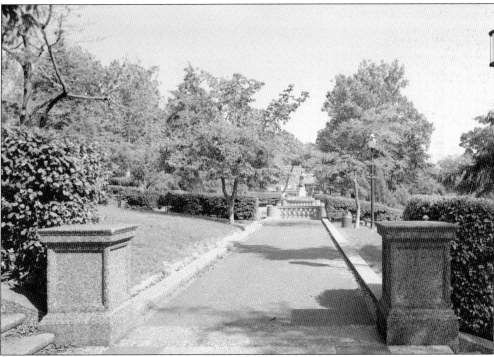

The park is divided into sections created by the major and minor park axis. Looking east along the minor east-west axis that divides the hillside of the lower park, the statue of Dante is seen at the terminal focal point. In the center view are two balustrades that are a part of the semicircular area that joins to the cascade stairway. (LOC.)

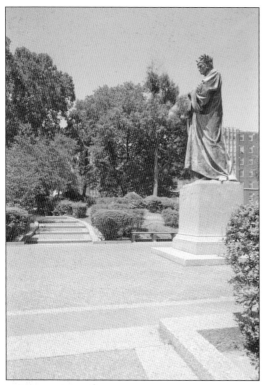

The Dante statue sits on the east side of the park in Poet's Corner. During the design and development of the park, architect Horace Peaslee was always protecting against the encroachment of more memorials. When the Dante statue was accepted by Congress and after the Commission of Fine Arts decided that the statue would be placed in Meridian Hill Park, Peaslee designed the area specifically for Dante while also keeping in mind the possibility of the need to accommodate more memorials. The statue is the eastern terminus of the east-west axis of the lower park. It is also located in the middle of the curving walkway on the east side of the lower park. The informal walkway joins the Buchanan memorial in the lower park to the great terrace wall east side stairs. There are two seating niches of molded concrete benches, flat wood slat benches in the plaza with the Dante statue, and two other wood slat benches along the walkway. (Left, LOC, below, NPS.)

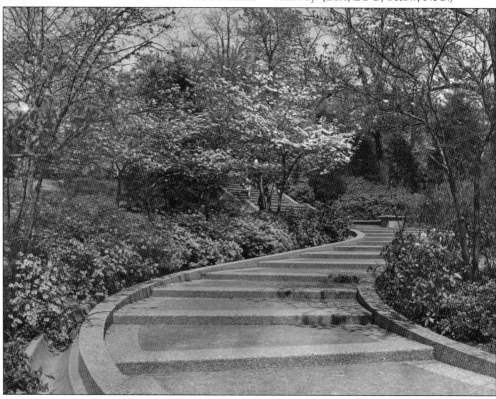

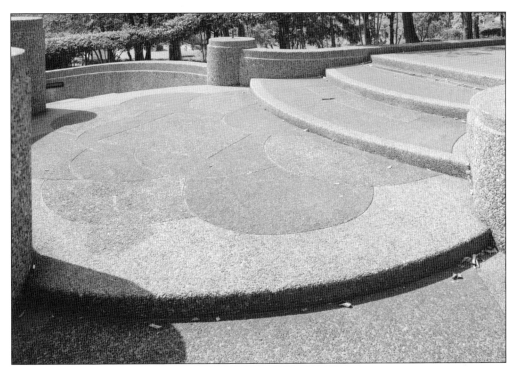

The concrete aggregate process used throughout the park was perfected by John Earley at the beginning of the project. Once the process was perfected, the styling of the aggregate became more creative, and the process was used by subsequent contractors. Mosaic designs similar to this were commonly used in Italian park design. Stylized walkways could be designed by using pebbles of different colors and sizes. (LOC.)

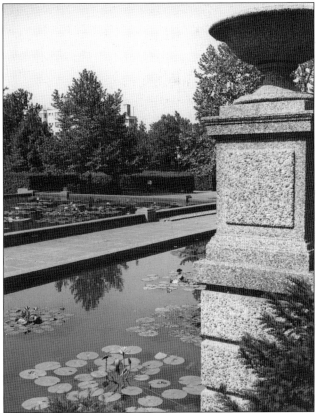

This image, looking southwest over the receiving pool of the cascades, shows the detail of the grooved pier and the fountain urn at the corner of the cascade walk balustrade. There are also four urn jets on the balustrades at the bottom that flank the last cascade basin. (NPS.)

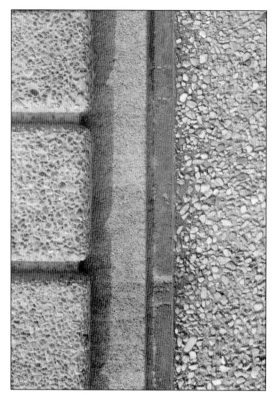

The architectural concrete used throughout Meridian Hill Park are some of the earliest and finest examples of its use. For the walls and piers, the mixture was one part Portland cement, two parts sand, and four parts broken stone (aggregate). The pebbles were from the Potomac River and were sorted by size. They created the color of the structure rather than the concrete. This architectural concrete was used on walls, balustrades, urns, obelisks, and benches. Some areas were finished by using chiseled forms, as seen below, to heighten the contrast. (Both, LOC.)

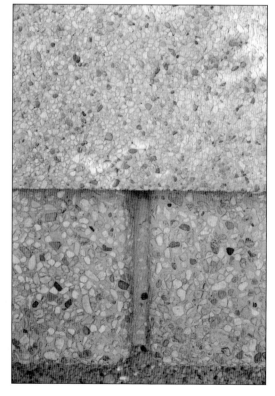

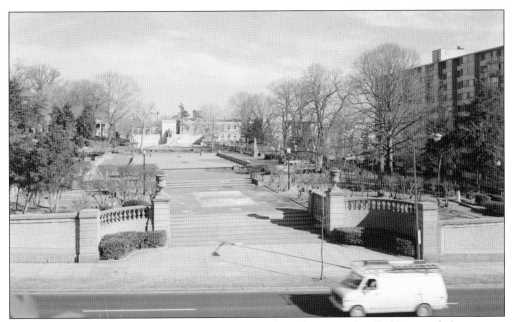

The main entrance to the lower park plaza is located on the west side off of Sixteenth Street near W Street. The curved walls topped with a balustrade create formality, while the evergreen hedge softens the entrance. The eight entry steps lead to a landing that gives access to the formal west ascent to the north. On the landing are 10 squares of polychrome patterned stars created with different colored aggregates. (LOC.)

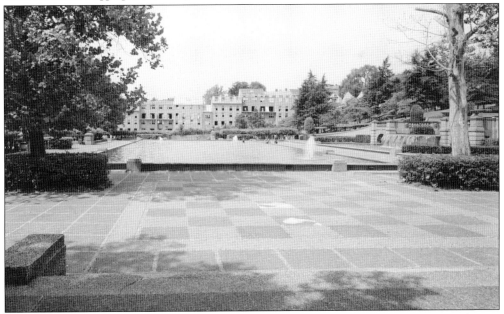

The lower plaza extends from the Lower Sixteenth Street entrance to the James Buchanan memorial. In the foreground is the chessboard made from alternate concrete squares made of beige and black trap located between the Buchanan memorial and the reflecting pool. The apartments in the background are the Beekman Place condominiums located where Boundary Castle once stood. (LOC.)

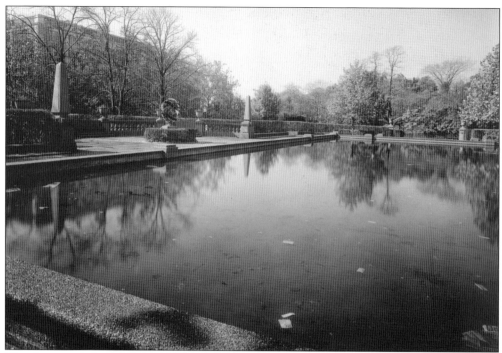

The design and planting plans for the reflecting pool included the addition of posts and urns on the coping as well as a hedge surrounding the pool. Neither proposal was implemented. The wide coping allows for seating and access to the water. The reflecting pool is 60 by 134 feet. (Courtesy of the Commission of Fine Arts.)

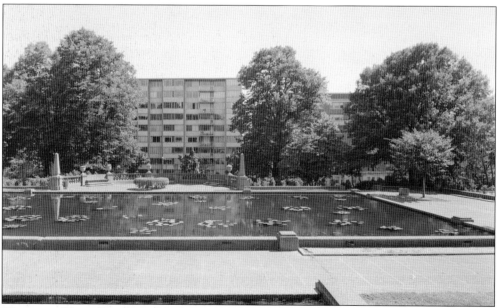

This view of the reflecting pool looking south shows an apartment building just south of the park that was erected in 1964. It was built to 10 stories and obstructed the view south. The reflecting pool is shaded by four oaks planted at each corner of the pool. For many years, the reflecting pool was planted with water lilies every year. The background shows the exedra. (LOC.)

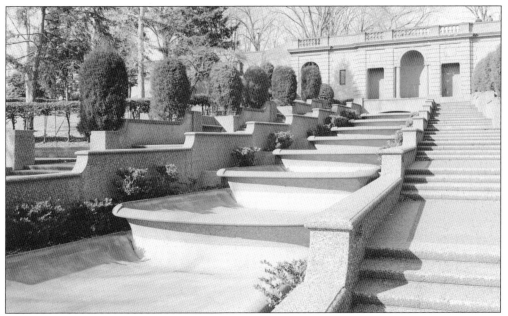

Detail of the concrete aggregate sidewalk is observable in this close-up of the cascades looking north. The cascade is lined with planting areas along the 13 basins, shown here, planted with evergreens. The walkway coping provides seating next to the water, and molded concrete benches were constructed as part of the walkway. American holly frames the benches, and the sight line is punctuated with cypress trees. (LOC.)

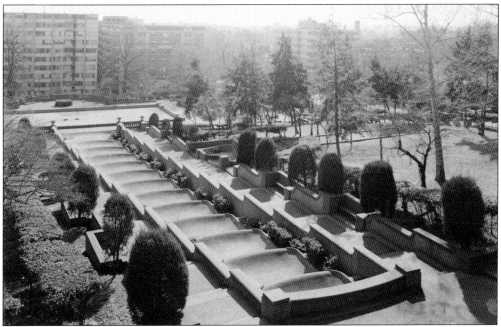

The 13 basins get wider toward the bottom of the cascade. Viewed from above, the basins have the appearance of being equal width. On either side of the cascade are plantings and a low, stepped concrete wall with generous coping. The low wall defines the cascade walkway that is lined with American holly and cedars. (LOC.)

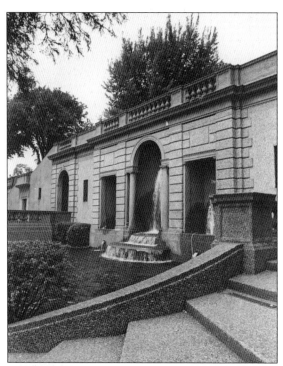

The east-west walkway that runs along the terrace wall is curved around the central pool at the beginning of the cascades. From there, the water runs under the walkway and into cascade basins. The recirculation system controls are located in the terrace wall and run down the cascades and drains and into the basin and reflecting pool. (NPS.)

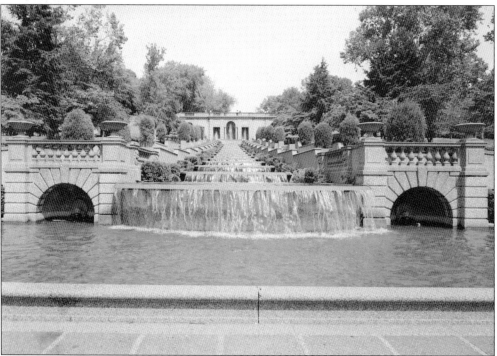

At the base of the cascade, the water pours into a catch bowl that is fed by four grotesque mask spouts mounted on the side walls. The landings have a balustrade and four fountain jet urns. The water flows from the cascade basins into the lower receiving pool, which has two dolphin spouts in niches underneath walkways. (LOC.)

The east and west walkways that run along the cascades create an overlook at a landing before the pathway curves around the catch basin. The landing provides views of the lower park, the catch basins, and the reflecting pool. The wall is made of a balustrade with grotesque water spouts. (NPS.)

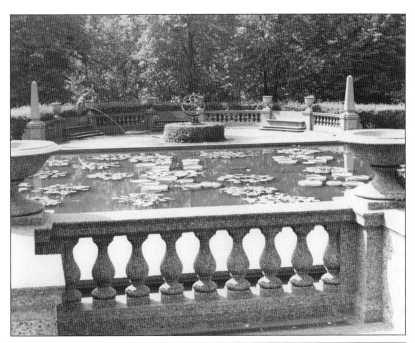

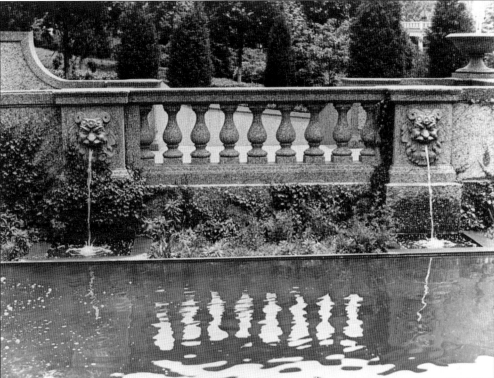

The southernmost cascade basin has four grotesque mask spouts mounted on the side walls. There are four urn jets on the balustrades at the bottom of the cascade walkway that flank the last cascade basin. The water flows from the cascade basins into the lower receiving pool, which has two dolphin spouts in niches underneath the balustrade landing. (NPS.)

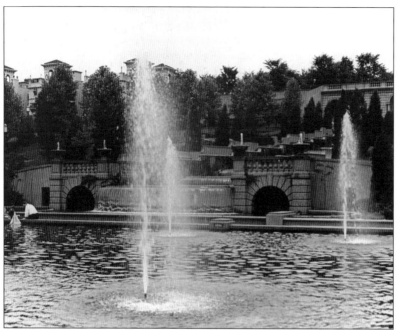

Shown here is the completed cascade with the hillside plantings in place and the fountain jets of the reflecting pool working. The hillside was excavated in 1931, and the cascade construction began in 1932 and was completed in 1933. The hillside along the cascades was planted with holly and cedars. (LOC.)

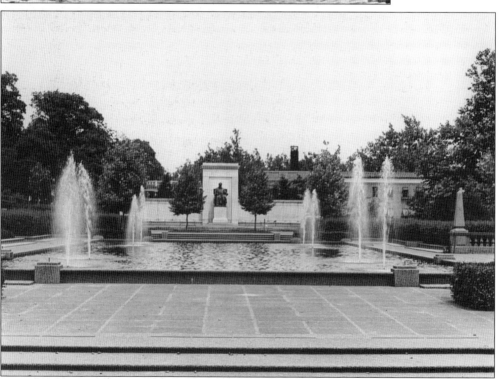

The lower plaza was constructed between 1928 and 1929. The water supply and the drainage system were put in along with the precast squares for the paved walks and the lower plaza. The reflecting pool was also developed during that time. At the corners of the reflecting pool, four elms were planted in 1930. By 1932, the water of the cascades and in the reflecting pool was flowing. (NPS.)

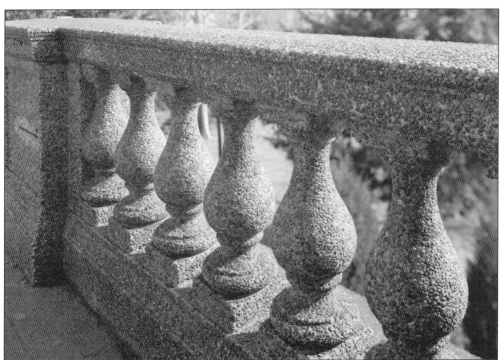

The balustrades used throughout the park were precast. The balustrades create detail and interest along many of the walkways. The precast balustrades were difficult to produce effectively. John Earley changed the casting technique to draw water out of the concrete using newspaper that then created strong molded casts with an ornamental effect. (LOC.)

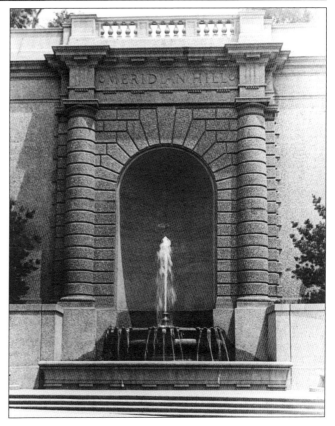

This fountain niche is located on Sixteenth Street directly beneath the great terrace. The rusticated arch is flanked with rounded and grooved pilasters, and above the fountain are the words "Meridian Hill." The original plans called for the niche to be hung with stalactite crystals gathered from the caverns at Luray, Virginia. The stalactites were gathered but never installed. (NPS.)

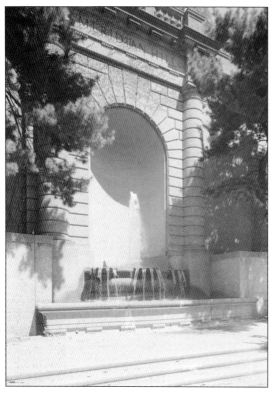

Because the park is walled, there were four entrances on the Sixteenth Street side of the upper park in the original plans. This fountain niche that sits directly under the great terrace was originally designed as the main entrance to the upper park. The stairs were to be within the terrace itself. In 1927, this entrance was eliminated, and it was then designed as a fountain. In the articulation and rustication, it is similar to the other arched niches in the park. At the base is a single fountain jet, and the basin is contrived of three shells, which the water spills over into a large lower basin. The niche is set back from the street and includes a stepped entry. There are molded concrete benches on either side of the fountain, and the wall rises to the balustrade of the great terrace overlook. The plantings from the hillside between the high and low retaining walls pour over. (Both, LOC.)

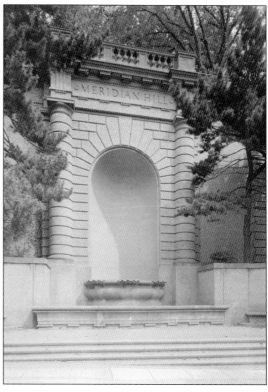

When the park was first designed, the plan called for the upper park to be accessible by car or carriage and included a series of carriageways and parking. The idea was to provide parking for people who wished to visit the park from outside the neighborhood. This was a unique park provision and one that recognized its potential appeal. In subsequent years, the plan was simplified. Inside the park, the carriageways became promenades, and parking was restricted to the outside of the park. The Fifteenth Street carriage entrance became a pedestrian entrance, with parking provided at Fifteenth and Chapin Streets. The Fifteenth Street wall was much shorter than the Sixteenth Street wall. The entrance to the park is flanked by two piers topped with obelisks, and closed urns mark the length of the entrance wall. (LOC.)

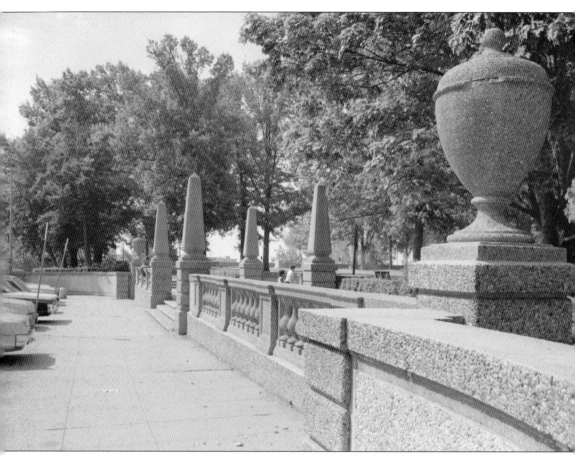

The main entrance to the park is on Sixteenth Street and leads to the upper mall. The Fifteenth Street side of the park was changed to accommodate the extension and expansion of Fifteenth Street. There is no public sidewalk on the park side. The wall was changed to be shorter and, therefore, not as imposing, and the plantings are less dense. There is a walkway in the park that follows the wall. There are four entrances on the Fifteenth Street side: one at the corner of Fifteenth and W Streets, a service vehicle entrance across from Belmont Street, an entrance across from Chapin Street (pictured here), and a pedestrian entrance at the corner of Fifteenth and Euclid Streets. The entrances along Fifteenth Street were designed for vehicles because areas of the upper mall were originally designed to accommodate carriage parking. (LOC.)

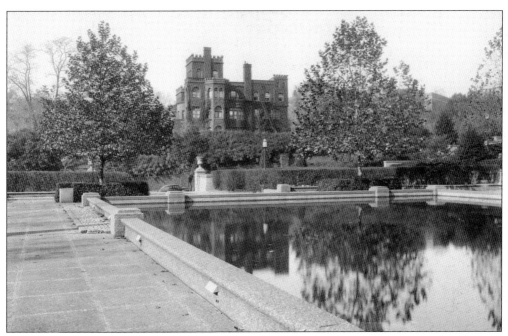

During the park's development, Mary Foote Henderson, who lived at Boundary Castle (above, background) across the street from the lower park, was persistent and successful in lobbying Congress for appropriations to complete the park. Before she died in 1931, the masonry portion of the park had been completed. The Commission of Fine Arts reported, in 1934, that she had visited the park before she died, writing, "During her last days with feeble steps she walked in the well-planted lower garden, quietly enjoying the beauty her patient labors had secured for generations to come." After Henderson's death, the Commission of Fine Arts considered creating a memorial for her in the park. One suggestion was to use the Sixteenth Street fountain niche, under the great terrace, for a memorial. Ultimately, no memorial to her was created. (Above, NPS; below, courtesy of the Commission of Fine Arts.)

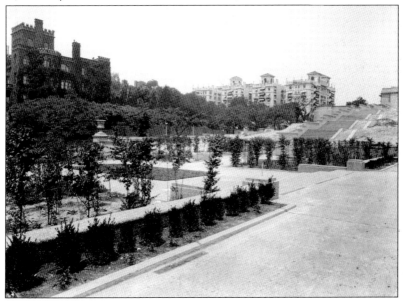

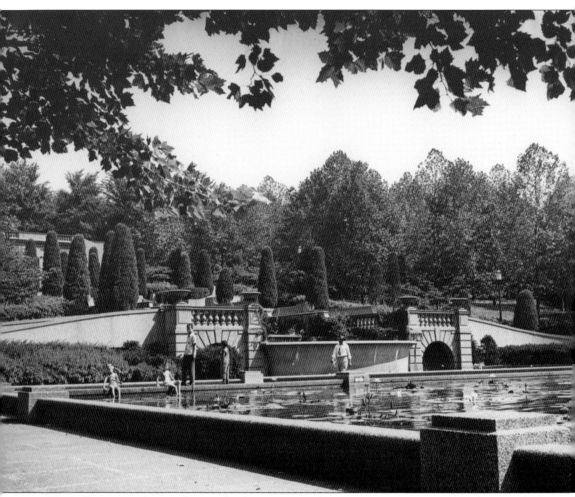

The reflecting pool, according to the Commission of Fine Arts 1929 report, was to be "enriched by the addition of posts and urn (12 antique oil jars filled with trailing vines), that will have their beauty reflected in the pool, as at the Villa d'Este at Tivoli, with perhaps two types of coping and of such height as to afford pleasure to children playing with boats at the edge of the pool." Despite the fact that the oil jars were never installed, the reflecting pool remains a focal point of the lower park. The pool was planted with lotus flowers and is framed by four large trees. The first trees planted were elms. These were replaced with sycamores with European hornbeam as a hedge and have themselves been replaced with zelkovas. The reflecting pool has a low wall of varying height and wide coping that defines the area and allows for seating. (NPS.)

Four

FROM NEIGHBORHOOD PARK
TO NATIONAL TREASURE
1936–1996

After opening in 1936, the park was immediately popular, and today retains much of its beauty, elegance, and wonder. The upper park was used for games of baseball, croquet, and soccer. The lower park was used by lovers and dog walkers, as well as for concerts and plays.

In the 1940s, the very popular Starlight Chamber Music series, organized by C.C. Chapel, ran during the summer for four years during World War II. Interestingly, the concerts were staged in the lower park, not from or around the grand terrace where George Burnap and Horace Peaslee had originally thought the concert area would be. The concert series brought many famous musicians and actors to Meridian Hill Park and ran from 1941 through 1944.

In the late 1960s and in various years in the 1970s, Summer in the Parks, a series of activities throughout the parks of the city, was organized. In 1969, on the anniversary of Martin Luther King's death, a leader of the Black United Front began referring to the park as Malcolm X Park. In 1970, a bill was introduced to officially change the name of the park to Malcolm X Park, but that bill was not passed. Despite that, or because of that, the name is still used by some.

Vandalism has always been a problem. The Serenity statue, placed in the park in 1925, almost immediately lost her nose and no longer has her right hand. The Joan of Arc statue regularly has her sword stolen and then replaced. And the armillary sphere—the most appropriate memorial in the park, according to Horace Peaslee—was damaged in the 1960s, removed for repair, and has never been seen again.

In 1974, Meridian Hill Park was listed in the National Register of Historic Places. Over the next two years, funds were used to repair and improve the park. In 1976, the National Park Service held a series of concerts and other activities that summer as a reopening.

During the 1980s, the park was filled with drug and crime problems. In 1990, Friends of Meridian Hill was formed. This neighborhood group patrolled the park; lobbied for the completion of certain proposals, including a play area for children; and held clean-up days. Then, in 1994, the park was given National Historic Landmark status. That year, on Earth Day, Pres. Bill Clinton announced the approval of the new status with a press conference in the park.

One of the longest-lasting gatherings in the park is the drum circle. Held every Sunday from 3:00 p.m. to sunset, the drum circle has been a place to come as you are, dance, sing, or just hang out since the late 1960s.

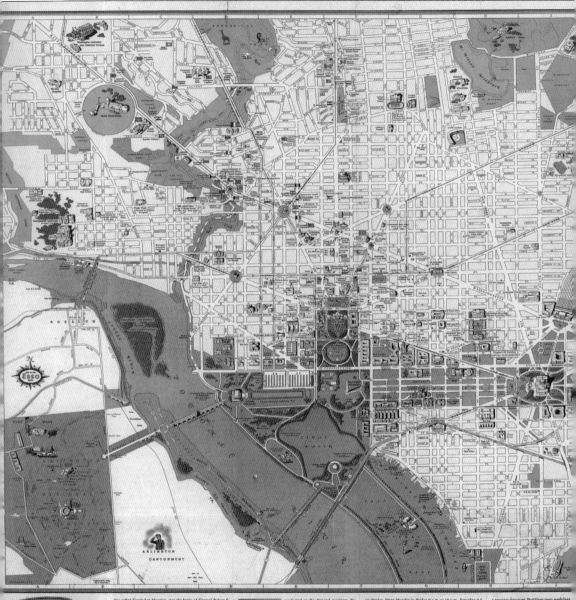

Visitor's Esso Guide to
WASHINGTON

Index numbers (A-1) refer to map charts which also locate other points of interest described here. As a written memory, buildings marked ★ were closed when this map went to press. Status of others may be changed without notice. For latest information call Esso Touring Service, National 4865.

AMERICAN PHARMACEUTICAL INSTITUTE (D-7). Historical pharmacy exhibits. Open Monday to Friday 9-5; Saturday 9-1.
★**AMERICAN RED CROSS** (E-7). Main building on 17th Street houses an extensive library and a museum containing numerous exhibits dramatizing some of Red Cross activities during war and peace. Open weekdays 8:30-4:30, Sundays 1-4:30.
AQUARIUM, Department of Commerce Building (F-7). About 100 species of freshwater fish. Most interesting is the collection of trout which includes albinos. Open Monday to Friday 9-4, Saturday 9-1:30.
★**ARCHIVES BUILDING** (G-7). One of the newest and most majestic federal buildings, housing historical documents and records. Open Monday to Saturday 9-4:30, Sunday 1:30-6.
ARLINGTON (A-9). Largest and most famous of America's military burial grounds. Resting place of the Unknown Soldier and other national heroes. Grounds open daily to sunset. Arlington House,

also called Custis-Lee Mansion, was the home of General Robert E. Lee. Here in the mansion's study he rejected the offer to lead the Union forces. Open 9-6 summer, 9-4:30 winter; admission 10 cents.
ARMY MEDICAL MUSEUM (G-8). Largest medical museum in the U.S. and world's largest medical library. Medical history portrayed in exhibits of surgical and medical equipment, specimens, and wax models. Open Monday to Friday 8:15-5, Saturday 8:15-12:15.
BOTANIC GARDENS (H-8). Outstanding horticultural displays may be viewed Sunday to Friday 9-4, Saturday 9-12.
★**BUREAU OF ENGRAVING AND PRINTING** (F-8). From elevated walkways visitors may observe the fascinating operation in the world's greatest currency-making plant. Frequent guided tours are made from Monday to Friday 8:30-11 a.m. and 1-2 p.m.
★**CAPITOL** (J-8). Gleaming white by day and floodlighted by night, the Capitol dominates the City of Washington. Spacious grounds, landscaped with hundreds of trees and shrubs, form a perfect setting for the massive building with its huge cast iron dome. Of outstanding interest are the chambers of the Senate and House of Representatives and many works of art. Open weekdays 9-4:30.
CHERRY TREES. Cherry-blossom time transforms large portions of Potomac Park (E-9) into great and lovely masses of white and pink. The single-blossom trees usually flower early in April, and the double-blossom trees a week or two later.
CORCORAN ART GALLERY (E-7). Sculptures, paintings, and other works of art. The Corcoran collection is especially interesting because it records the chronological development of American art. Open Monday 12-4:30, Tuesday to Saturday 9-4:30, Sunday and holidays 2-5. Admission Monday, Wednesday, and Friday 25 cents.
DUMBARTON OAKS RESEARCH LIBRARY (C-4). Collection of Byzantine and Early Christian art objects of metal, ivory sculpture, and textiles. Open weekdays 10-4.
★**EMBASSIES AND LEGATIONS.** Some of the most imposing are to be seen on Massachusetts Avenue. All are located on the map by flags and are identified by "No Parking" signs and names on curbs.
★**FEDERAL BUREAU OF INVESTIGATION,** Department of Justice (G-7). The laboratories, fingerprint files, crime museum, and other activities of the "G-Men" are shown and explained to visitors on guided tours

conducted as the demand warrants. Exhibits from the latest and most notorious cases may be seen also. Building open Monday to Friday 9:30-5, Saturday 9:30-12:30.
★**FEDERAL RESERVE BUILDING** (E-7). This monumental new white marble structure typifies the classic architecture of the federal buildings. Open Monday to Friday 9-4:30, Saturday 9-1.
FOLGER SHAKESPEARE LIBRARY (K-8). This world-famous collection of Shakespeare material assembled by the late Henry C. Folger contains 85,000 volumes including First Folios and later research material. Fluent collection of its kind outside of England. Exhibition gallery and reproduction of Elizabethan courtyard theatre open Monday to Saturday 9-4:30.
FORD'S THEATRE (Lincoln Museum) (G-6). Scene of the assassination of President Lincoln. Exhibited here are many of Lincoln's books, furniture, mementos of his presidential campaign, and newspaper accounts and relics of his assassination. Open weekdays 9-4:30, Sunday and holidays 12:50-4:30. Admission 10 cents.
FREER GALLERY OF ART (G-8). Notable collection of Asiatic art and numerous paintings and etchings by James Whistler may be seen by visitors daily except Monday 9-4:30.
★**GOVERNMENT PRINTING OFFICE** (H-6). World's largest and best-equipped printing plant, covering many acres of floor space. Among documents, pamphlets, and other material printed here is the Congressional Record. 90-minute tours conducted Monday to Friday 10-3, Saturday 10-11, as the demand warrants.
INTERIOR DEPARTMENT MUSEUM (E-7). Graphic presentations of the work of the Department's bureaus including Reclamation, Indian Affairs, National Park Service, Mines, U.S. Geological Survey, and the Division of Territories and Island Possessions. Open Monday to Friday 8-5:30, Saturday 8-2.
LIBRARY OF CONGRESS (J-8). One of the world's greatest libraries. Foremost among its nearly 10,000,000 items are the originals of the Declaration of Independence and the Constitution of the United States. A Gutenberg Bible and other historic documents also are

on display. Open Monday to Friday 9 a.m. to 10 p.m., Saturday 9-6, Sunday and holidays 2-10.
LINCOLN MEMORIAL (D-8). Magnificent white marble building at the west end of the Mall. Interior is dominated by a huge seated statue of Lincoln by Daniel Chester French. Strikingly lighted at night. Open daily 9 a.m. to 9:30 p.m.
MEMORIAL CONTINENTAL HALL (E-7). Headquarters of the National Society of the Daughters of the American Revolution. Museum of Revolutionary War relics and many state chapter rooms furnished in Colonial style. Open Monday to Friday 9:30-4:30, Saturday 9-1.
NATIONAL ACADEMY OF SCIENCES (D-7). The wonders of nature are strikingly illustrated in a series of exhibits, including working models. (Closed during the national emergency.)
NATIONAL GALLERY OF ART (G-7). The "American Louvre." Paintings and sculpture, including the noted Mellon and Kress collections. Building given by the late Andrew W. Mellon. Open weekdays 10-5, Sunday 2-5.
NATIONAL GEOGRAPHIC SOCIETY (F-5). Here in Explorers' Hall are trophies of Geographic Society expeditions and many dramatic photographic enlargements. Open Monday to Friday 9-5.
PAN AMERICAN UNION (E-7). North and South American architecture is blended in this structure. A tropical climate maintained inside permits the growth of palms, bananas, coffee, and rubber. Striking relief maps, models, photographs, and tropical birds. Open Monday to Friday 9-4, Saturday 9-12:15.
PHILLIPS MEM. GALLERY (D-4). Modern French and American paintings with a few Old Masters. Open weekdays 11-6, Sunday 2-6.
POST OFFICE DEPARTMENT (G-7). An extensive philatelic exhibit is maintained here. Open Monday to Friday 8-4:30, Saturday 8-12:30.
SMITHSONIAN GROUP (G-8). World-famous Smithsonian Institution contains natural history and scientific exhibits from many lands. Other buildings are the New National Museum containing natural history exhibits, the Old National Museum featuring arts and industries. An aviation display is in

a separate structure. Buildings open weekdays 9-4:30.
SUPREME COURT (J-8). This fine example of one of the more magnificent of the newer Open weekdays 9-4:30 (closed Saturday afternoons).
WASHINGTON CATHEDRAL (B-1). One of the ly designed ecclesiastical structures in America. weekdays 9-5, Sunday following 11 a.m. service.
WASHINGTON CHAPEL ("MORMON") (F-1). Utah marble. Guided tours following organ recital, weekdays, and Saturday at 8 p.m.
WASHINGTON MONUMENT (F-8). Stately and 555 feet and dominating the Mall. Wide-open vistas from observatory reached by elevator.
★**WHITE HOUSE** (F-6). This essentially simple point for many broad avenues. General visiting the national emergency; service men in uniform limited hours Friday and Saturday.
ZOOLOGICAL PARK (D-1). Outstanding collection of animals and reptiles Open daily 9-5. Feeding times: elephants 2:30; lions and tigers 3:30 except small mammals 2:30.

6693575

100

When the park officially opened in 1936, much of the neighborhood—and indeed, Washington, DC, in general—had changed quite a bit. The surrounding neighborhood had grown and changed since 1910. Mary Foote Henderson had died in 1931. However, since 1910, she had greatly influenced the growth the neighborhood. She and George Oakley Totten Jr. had built three mansions fronting Meridian Hill Park on Fifteenth Street, along with six mansions on Sixteenth Street. This map from 1942 shows the legations that were housed in mansions that Henderson had built. The neighborhood would continue to change, with many of the legations and embassies moving out of the neighborhood by the 1970s. The surrounding area got denser with the building of apartment buildings and condominiums around the park, including Beekman Place, located on the site where Henderson Castle once stood. Other apartment buildings included the Hadleigh (now the Roosevelt) to the south and Park Tower Condominiums along Sixteenth Street. (LOC.)

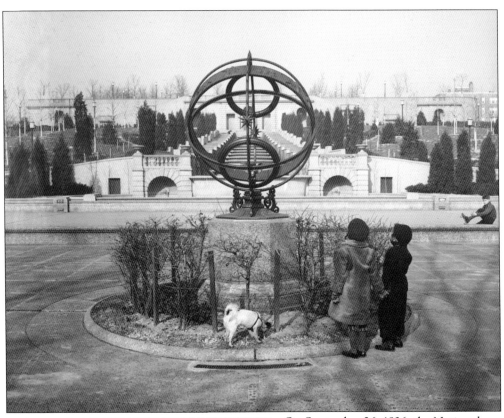

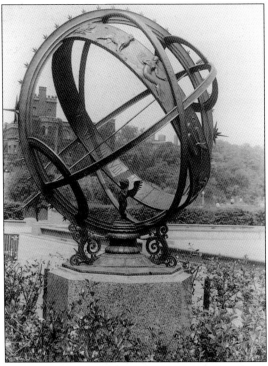

On September 26, 1936, the National Capital Parks announced that work on Meridian Hill Park had been completed and that the project was finished. That it had taken 26 years and almost $1.5 million was without precedent in America. The Italianate park, which could be compared to the most beautiful, private Italian Renaissance parks, was free and open to everyone. (Above, reprinted with permission of the DC Public Library, Star collection, © Washington Post; left, NPS.)

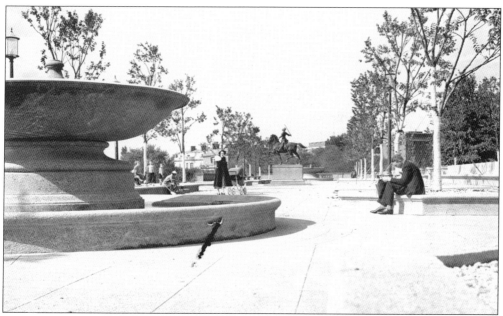

By the time the park opened in 1936, the neighborhood had a mixture of apartment buildings and grand houses. Mary Foote Henderson, a great influencer of the neighborhood and park, had died in 1931. Her mansion, Boundary Castle, had been turned into a club, and would later be torn down. The view to the south had been lost in 1919 with the construction of the Hadleigh Apartments, and the French embassy had moved out of the neighborhood. However, the park was immediately popular, not only as a neighborhood park, but because of the brilliance of the design. Shown here in October 1932, the great terrace is lined with low planter boxes one foot high with wide coping that could be used for seating. The boxes are used for trees and benches. Behind the raised boxes and creating separation between the terrace and the mall are low, four-foot walls with molded benches. (Both, reprinted with permission of the DC Public Library, Star collection, © Washington Post.)

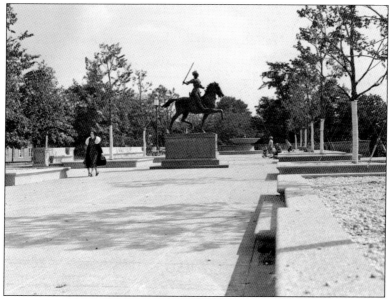

By the time Meridian Hill Park opened, it was part of the National Park system. During development, the park had been managed through the Office of Public Building and Parks of the national capital, which had been absorbed by the National Park Service in 1933. Although organized sports were discouraged, the upper park mall was perfect for lawn sports. During the 1920s and 1930s, the mall was used for croquet (as seen above) and quoits—a game similar to horseshoes. Among the other activities was the First National Capital Air Derby miniature balloon race in 1935, pictured below. (Both, NPS.)

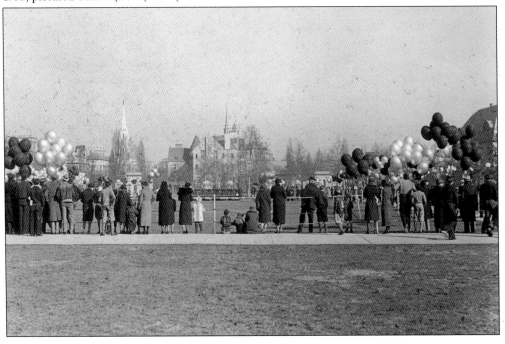

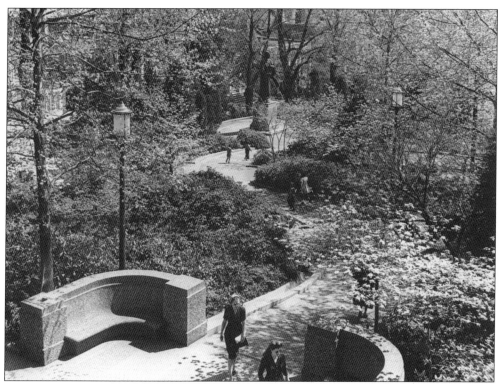

The images here are from the hillside gardens during the height of the plantings. The east ascent, seen above, runs from the lower park plaza to the niche at the base of the great terrace steps. The Dante statue stands off to one side at the halfway point of the east ascent. The extensive landscaping of the hillside included sycamores, dogwoods, and shrubs. Separating the cascades from the hillside terrace is a holly hedge and tall cedars. Along the ascent are alcoves with backless, wood slat benches defined by plantings. Pictured below is the curved walkway that winds around the first catch pool of the cascades. The water runs under the walkway and into the first cascade basin. The corners are heavily planted to bring focus to the fountains and the cascades. (Both, NPS.)

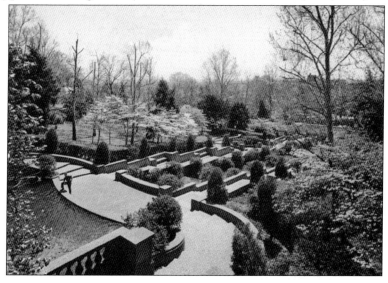

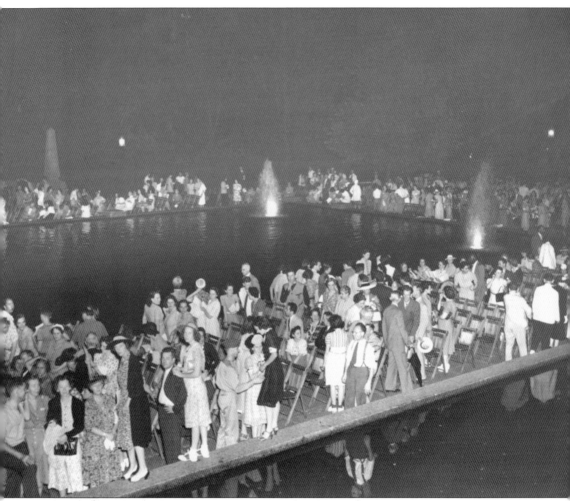

The Starlight Chamber Music series began in 1941 and ran through 1944. It was organized by C.C. Cappel, a former manager of the National Symphony Orchestra. The idea of holding chamber music outside of a "chamber" was a unique experiment and one that became very popular. The first summer series ran for six weeks from July to August. It was held in the lower park area. Horace Peaslee, the park's architect, designed a rectangular, acoustical shell for concerts that was placed in front of the Buchanan memorial and opened to the west. The seating, which cost 25¢ for general seating and 50¢ for reserved seating, accommodated 2,000 people and was arranged around the reflecting pool. This image shows the capacity crowd at the Salzedo Harp Ensemble concert on July 18, 1941. The fountains were turned on and lighted at intermission and after the performance. (Reprinted with permission of the DC Public Library, Star collection, © Washington Post.)

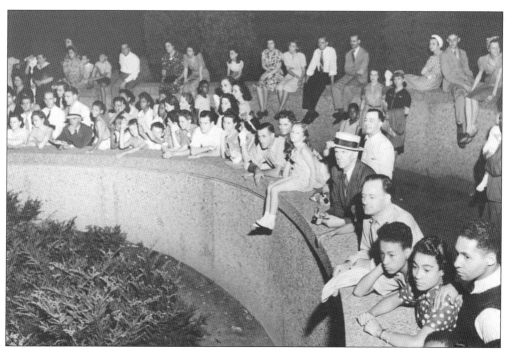

The Starlight Chamber Music series was sponsored by the Starlight Chamber Music Committee, and later the *Washington Post*, in cooperation with the National Capital Parks Service, and ran for four summers, from 1941 to 1944. Seating was available for purchase, but the concerts were free to anyone. The overflow crowd sat along the walls of the cascades or wherever they could find. (Reprinted with permission of the DC Public Library, Star collection, © Washington Post.)

There were many famous performers during the first summer of the Starlight series, including the Trapp Family Singers, who made their Washington, DC, debut. Reportedly drawing one of the largest crowds of the summer of 1941, the Trapp Family Singers performed a variety of music, including folk songs. There were eight members of the group, including the Baroness von Trapp, five daughters (pictured here), and two sons. (LOC.)

Martha Graham and her dance troupe gave two performances, on July 21 and July 23, 1942, as part of the Starlight series in Meridian Hill Park. Graham was considered one of the most influential American dancers of the 20th century. The troupe's performance on July 21 included "Letter to the World" and "Punch and Judy." On July 23, the troupe performed "Every Soul is a Circus" and "American Document." (NPS.)

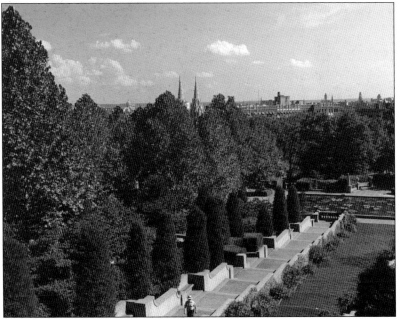

By the 1940s, the park was at its peak. It was during this period when the Starlight Chamber Music series began and ran through the summer of 1944. This image from 1946 shows the trees filled out, the hedges trimmed, and the sidewalks in good shape. (NPS.)

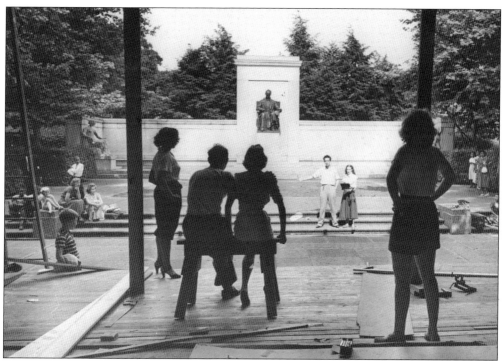

In 1949, performances returned to Meridian Hill Park. In the 1940s, there was a push to integrate the audience at the National Theatre, which failed. In 1948, the theater chose to close rather than allow integration. An integrated investment group of more than 60 people, known as the Washington Theater Festival, raised $18,000 to finance a summer theater in Meridian Hill Park. Forty-five percent of the investment group was African American. In June 1949, construction began on a stage in the lower part of the park under the direction of Vincent Donehue using plans drawn up by David Arron. The image above shows the view from the theater stage and the view below looks toward the stage. The seating was set up in front of the Buchanan memorial. (Both, reprinted with permission of the DC Public Library, Star collection, © Washington Post.)

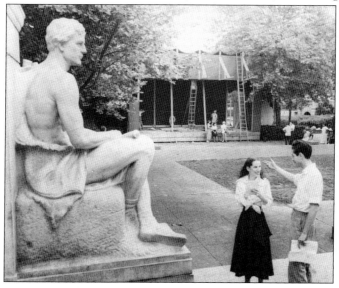

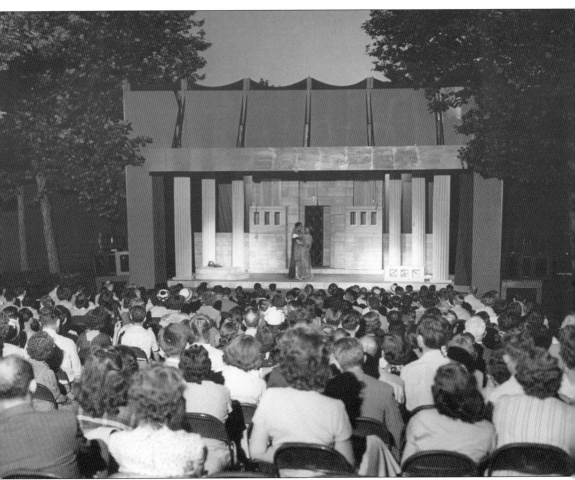

The creation of the Washington Theater Festival was a direct result of the National Theatre's refusal to integrate its audience. The season at Meridian Hill Park was the first professional theater to operate in Washington, DC, in more than a year when it began in the summer of 1949. The first performance of the Washington Theater Festival's season in Meridian Hill Park was a production of Giraudoux's *Amphitryon 38* starring Elisabeth Bergner (pictured here) that opened the weekend of June 26, 1949. The stage was 36 feet wide by 24 feet deep and covered in waterproof canvas, with microphones suspended from the ceiling. Tickets ranged in price from $1.20 to $3.60, and there was seating for 917. During the 1949 season, between 10 and 15 percent of the audience in Meridian Hill Park was African American. The summer productions made a profit, which is practically unheard for a theater in its first season. (NPS.)

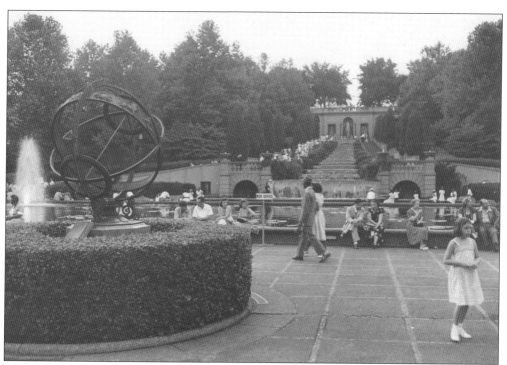

The non-segregated theater in Meridian Hill Park opened in June 1949 for an eight-week run that was extended to 11 weeks. The season was very popular and drew crowds throughout the summer. The performances generally ran for a week and included some of the biggest stars of the 1940s. Estelle Winwood and John Buckmaster performed in *The Importance of Being Earnest*, Buster Keaton in *Three Men on a Horse*, Eddie Dowling in *The Time of Your Life*, Edit Atwater and Helmut Dantine in *No Time for Comedy*, Vicki Cummings and Alexander Kirkland in *Design for Living*, Tom Ewell in *The Maile Animal*, Nancy Coleman and John Beal in *The Voice of the Turtle*, and Libby Holman, Donald Burr, and Peter Fernandez in *O Mistress Mine*. (Both, NPS.)

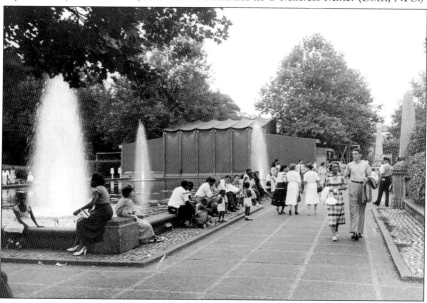

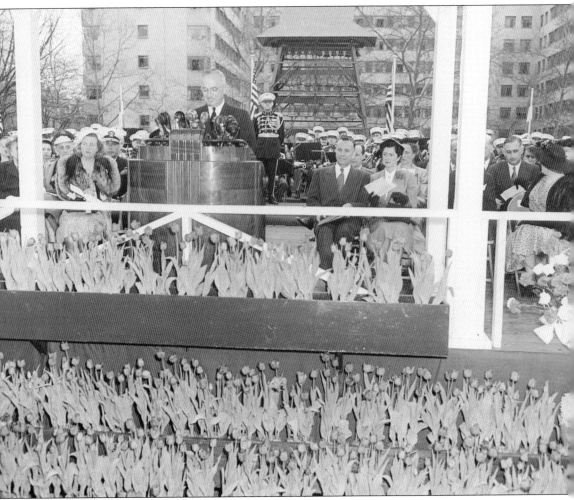

In April 1952, Queen Juliana of the Netherlands presented a gift of a carillon to Pres. Harry S. Truman. The ceremony took place on the upper mall of Meridian Hill Park and included the installment of a temporary carillon with 32 bells. The gift from the Netherlands to the United States was a symbol of gratitude for help given during and after World War II. According to reports in the *Washington Post*, Queen Juliana presented an array of bells, saying, "So many voices in our troubled world are still unheard. Let that be an incentive for all of us when we hear the ringing of the bells." Truman accepted the gift, expressing that "no gift could be a better symbol of the harmonious relations which have always existed" between the Netherlands and the United States. There were about 8,500 spectators for the ceremonies. (Courtesy of the National Archives.)

The temporary carillon was located in the park from 1952 until 1954 before being moved to West Potomac Park. During the ceremony, a group of children sang Dutch folk songs. The group also serenaded the queen upon her arrival. After the ceremony, the bells of the temporary carillon were rung. (National Archives.)

In 1954, a total of 49 permanent bells arrived from the Netherlands, and the carillon was moved to West Potomac Park and eventually to Rosslyn, Virginia. Each bell was donated and decorated by a different Dutch group using appropriate designs and verses. The permanent carillon has 50 bells ranging in size from eight inches high to six feet high and weighing between 42 pounds and 6.5 tons. (NPS.)

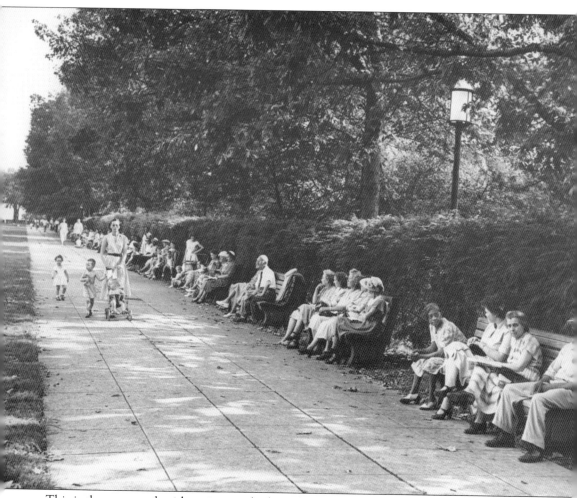

This is the upper park with a view south along the "concert promenade." From the beginning, the park attracted large numbers of visitors. There are 31 benches on each side of the mall. These benches, with curved concrete bases and wood seating, were not installed until 1936. Temporary benches had been in place on the upper mall from the time it opened to the public. Although the seating in the lower park included molded concrete benches and seating nooks, as well as wooden benches, almost all of the seating in the upper park is located along the promenades. Also seen here are the light posts. Lighting was actually a contentious issue. Vandalism was a problem from as early as 1923. Park lighting, however, should add to the aesthetic of a park and not be as bright as street lights. There are 53 light posts with fluted steel poles and Saratoga luminaires that were installed in the park in 1936 by the Potomac Electric Power Company. (NPS.)

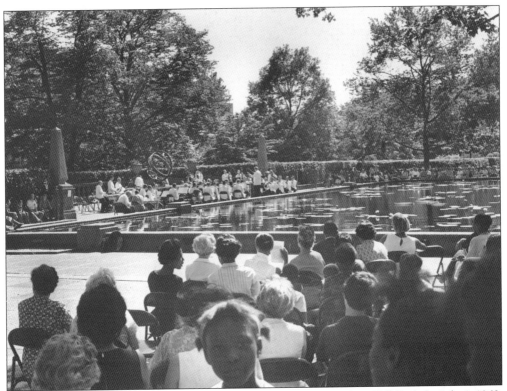

After a hiatus of almost 20 years, a concert was organized at Meridian Hill Park for July 4, 1963, in cooperation with the National Capital Parks and the University-Neighborhoods Council, the Music Performance Trust Funds, and the Washington local of the American Federation of Musicians. There were several performances throughout the summer. Shown here is the Watergate Symphony Orchestra performance. (NPS.)

Concerts frequently took place in the park with support from the National Park Service. The events were free; however, tickets were sold for those wanting seats that were set up around the reflecting pool. The arrangement shown here, from a concert on July 4, 1963, shows the musicians in the exedra. There was no sound system, only natural acoustics. (LOC.)

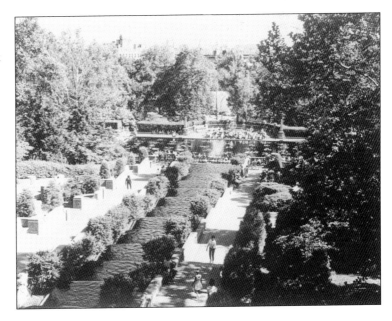

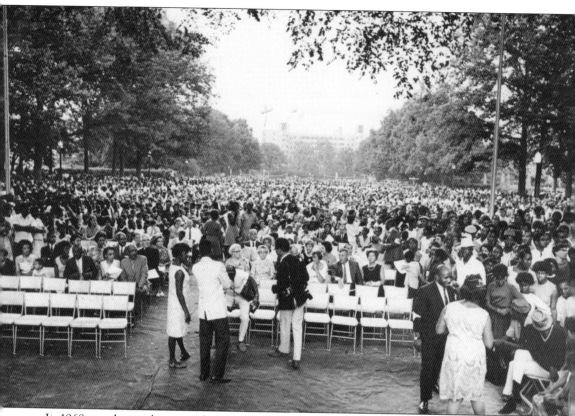

In 1968, another push was made to increase programming and usage of the national parks. The National Parks Service planned activities throughout the city for Summer in the Parks. The kickoff to Summer in the Parks was held in Meridian Hill Park on Sunday, July 14, 1968. Chairs were set up on the lawn of the upper park, and a stage was created near the great terrace. The hostess for the kickoff party for the Summer in the Parks program at Meridian Hill Park was Perle Mesta, a well-known social hostess in Washington. The program had been created with the help of George Hartzog, director of the National Park Service, and had organized activities in 20 parks around the city. The activities ran throughout the day and night. (Reprinted with permission of the DC Public Library, Star collection, © Washington Post.)

The Summer in the Parks program was the brainchild of Russel Wright, a well-known industrial designer. Wright was hired as a consultant to update some of the national parks in the capital. In Meridian Hill Park, Wright installed bigger and brighter bulbs but had the light posts set back from the pathways to retain the design integrity. While consulting for the National Park Service on renovations, Wright thought up the idea of Summer in the Parks as a way to get people into the renovated parks. The show featured Pearl Bailey, Cab Calloway (pictured at right), Hildegarde, and Gene Donati's 22-piece orchestra. It was reported that 20,000 people participated in Meridian Hill Park. Activities were held throughout the summer in several of the district's national parks. The Lou Rossi Octet, pictured below, also performed for early guests at the kickoff to Summer in the Parks. (Right, LOC; below, reprinted with permission of the DC Public Library, Star collection, © Washington Post.)

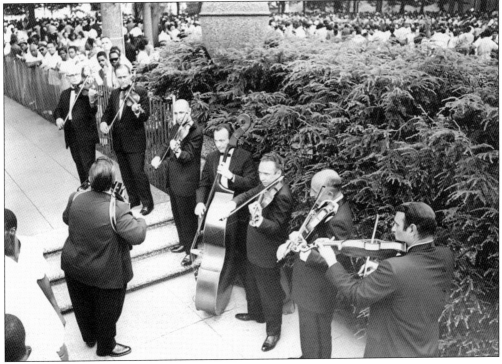

The park has always had issues with vandalism and graffiti, going back to the 1920s. The Serenity statue has also been the victim of vandalism. Serenity's nose was broken off in the 1950s, and her right hand is missing, as are two fingers on her left hand; the statue was also a victim of graffiti. The Buchanan memorial, pictured above, has long been a victim of graffiti, possibly due to its expansive wall. But the two figures flanking the memorial have also been vandalized, with the right toe of the large male figure broken off. The sword that Joan of Arc holds high is routinely broken off and stolen. (Both, LOC.)

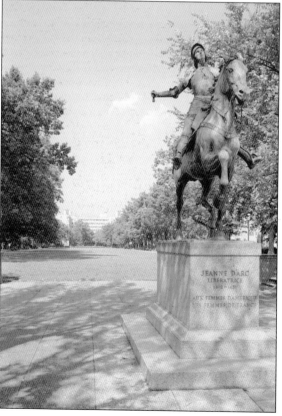

The Summer in the Parks program ran from 1968 until 1975, when budget shortfalls required program cuts. However, during those eight years, it had been extremely popular and provided activities in 14 parks throughout Washington, DC. Because of its popularity, the program expanded its offerings. One new activity was the National Environmental Education Development program for environmental studies, which was first offered in 1970. In the photograph above, an eighth grader visits Meridian Hill Park and learns about "Mr. Non-polluting Garbage Disposal." Before Summer in the Parks, Meridian Hill Park was considered one of the most dangerous parks in the city. The Summer in the Parks program brought back awareness of the park to the neighborhood as well as activities, people, and renewed interest in the park, which also brought a dramatic decrease in crime. (Above, reprinted with permission of the DC Public Library, Star collection, © Washington Post; below, NPS.)

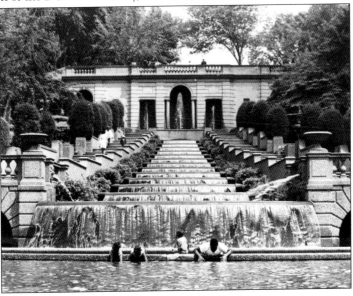

Meridian Hill Park became a gathering place for protestors during the 1960s and 1970s. On July 19, 1968, Walter E. Fauntroy, vice chairman of the district's city council, pastor at New Bethel Baptist Church, and one of the leaders of the Black United Front, organized a rally in Meridian Hill Park where speakers talked about the local police department's shooting of Theodore Lawson, an unarmed African American, on Fourteenth Street NW seven days prior. The group also charged that the police department had not taken right action on a large number of complaints by citizens and African American officers. The Black United Front was credited with first calling Meridian Hill Park "Malcolm X Park" beginning in 1969. A bill to change the name of the park was introduced in Congress, but it was not passed. (Reprinted with permission of the DC Public Library, Star collection, © Washington Post.)

By the 1980s, the park had become neglected and was considered one of the most dangerous parks in Washington. It was also in need of maintenance and renovations. The renewal of Meridian Hill was gradual. The Friends of Meridian Hill Park was formed in 1990 and helped rescue the park. As crime dropped, use of the park increased, including jogging and dog walking. (Reprinted with permission of the DC Public Library, Star collection, © Washington Post.)

Friends of Meridian Hill was organized by the community to make the park safe again, hold community clean-up days, and organize community events. The group was formed in 1990 by Rev. Morris Samuel, Howard Coleman, and Josephine Butler and led by Steve Coleman. Today, the group has expanded citywide to become Washington Parks & People, based in the Josephine Butler Parks Center across the street from the park. (NPS.)

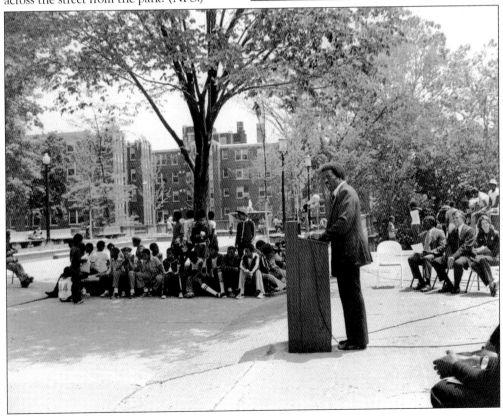

This image looking north shows a view of the upper park toward Euclid Street. The building in the background is a Howard University dormitory, but it originally was built as the Meridian Hill Hotel for Women in 1942. The land on the north side of Euclid Street from Fifteenth Street and Sixteenth Street was vacant when the French government purchased the land in the 1930s with the intention of building a new French embassy and consulate there. There is a flower garden that runs along the wall on the inside of the park. The imposing building changed the varied skyline of the northern vista. (Jeffrey Wilkes.)

In the first year of the Friends of Meridian Hill, group president and founder Steve Coleman raised money to sponsor an encampment of Civil War reenactors and a Fourth of July concert. On July 4, 1990, a reenactment of the 54th Massachusetts regiment took place on Meridian Hill. Col. Robert Gould Shaw, who commanded the 54th, had served in the 7th New York Militia, which had camped on Meridian Hill during the Civil War in 1861. Other activities on that Independence Day included a park cleanup and a concert by Bo Diddley Jr. and company. (Both, courtesy of Washington Parks & People.)

From 1990 to 1994, a total of 900 members of the Friends of Meridian Hill, along with the National Park Service and the US Park Police, worked to reclaim Meridian Hill Park. The Friends of Meridian Hill collected trash, planted trees and flowers, and scrubbed statues and walkways. After years of work, on Earth Day 1994, Pres. Bill Clinton delivered an environmental address in the park to about 500 invited guests. For the event, the walkways had been swept clean, the graffiti had been washed away, and flowers had been planted in urns. In May 1994, Steve Coleman, president and founder of Friends of Meridian Hill, and Josephine Butler, vice president, were honored with the National Park Foundation Partnership Award by President Clinton. The park also was designated a National Historic Landmark in 1994. (Both, courtesy of Washington Parks & People.)

SPECIAL GUEST

Earth Day Address

President Clinton and Vice President Gore
Thursday, April 21, 1994
Meridian Hill Park
16th and Euclid Streets
Washington, DC
Gates will be open from 9:00 to 10:30

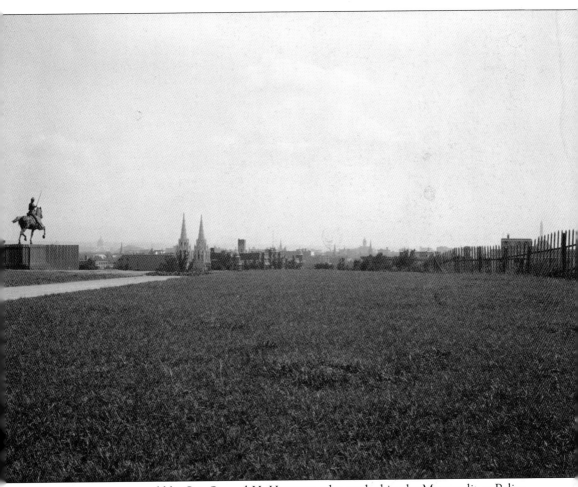

There is a great story told by Sgt. Samuel H. Hartung, who worked in the Metropolitan Police Department, to Jack Jonas, who retold it in the *Washington Post*: "I wonder how many of the boys are still around who grew up in the vicinity of Sixteenth And U streets, N.W., who will remember the present Meridian Hill Park was known to us as 'Sixteenth Street Hill?' It was just a huge sand dune covered with broom straw. I also wonder if the kids of today have as much fun amongst the beauty found there as we did back about 1912 to 1917? . . . How well I remember flying kites from this hill when the wind was from the East, while watching workmen excavate for the building of the present Hotel 2400, and the times Mrs. Henderson chased us from the swimming pool of her home, Henderson's Castle, which was just across Sixteenth Street from the 'Hill.' " (Courtesy of the Commission of Fine Arts.)

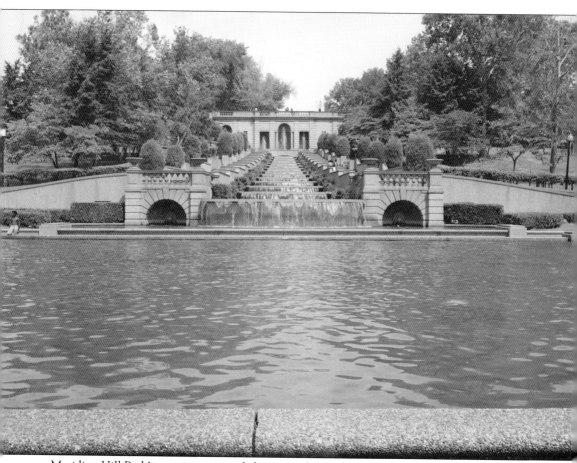

Meridian Hill Park's amazing accomplishment is the successful combination of the masonry and plantings that also takes advantage of the location and view to create one of the most unique parks in the National Park System. In 1959, Horace Peaslee walked through the park with George Kennedy while discussing the park's history and, at the time, underuse. "It's too bad," said Peaslee to Kennedy, as reported in the *Evening Star*, "when you think of the number of people who go to Italy to see the Gardens of Rome. Here is a formal garden combining much of the best of the gardens of Italy, and so few people make use of it." From 1936 until his death in 1959, Horace Peaslee had remained an advocate for Meridian Hill Park, occasionally writing letters to the Commission of Fine Arts or requesting the completion of a design that had not been finished. Today, Meridian Hill Park is being used and appreciated. (LOC.)

BIBLIOGRAPHY

Architrave P.C. Architects, and US National Park Service, National Capital Region. *Meridian Hill Park Cultural Landscape Report*. Washington, DC: US Department of the Interior, National Park Service, 2001.

Aument, Lori. "Construction History in Architectural Conservation: The Exposed Aggregate, Reinforced Concrete of Meridian Hill Park." *Journal of the American Institute for Conservation* 42.1 (2003): 3–19.

Bethune, Mary McLeod. "Meridian Hill Park is Move Toward Democracy in Capital." *Chicago Defender*. July 9, 1949.

Burnap, George. *Parks: Their Design, Equipment and Use*. Philadelphia, PA: J.B. Lippincott Company, 1916.

Earley, John J. "Some Problems in Devising a New Finish for Concrete." *Proceedings of the American Concrete Institute*. Vol. 14, 1918.

————. *The Concrete of the Architect and Sculptor*. Chicago, IL: Portland Cement Association, 1926.

Hecht, Marie B. *John Quincy Adams: A Personal History of an Independent Man*. New York, NY: The Macmillan Company, 1972.

Kohler, Sue A. *Sixteenth Street Architecture*. Washington, DC: The Commission of Fine Arts, 1978.

Meridian Hill Park: Cultural Landscape Report. Vol. 1. Washington, DC: National Park Service— National Capital Region.

Meridian Hill Park, Historical American Buildings Survey, No. DC-532. Washington, DC: National Park Service, 1985.

Porter, David Dixon. *Memoir of Commodore David Porter, of the United States Navy*. Albany, NY: J. Munsell, 1875.

Steiger, Richard W. "John J. Earley: Architectural Concrete Pioneer." *Concrete Construction*. The Aberdeen Group, 1995.

Wheeler, Linda. "Reclaiming Park's Lost Glamor." *Washington Post*. March 29, 1990.

DISCOVER THOUSANDS OF LOCAL HISTORY BOOKS FEATURING MILLIONS OF VINTAGE IMAGES

Arcadia Publishing, the leading local history publisher in the United States, is committed to making history accessible and meaningful through publishing books that celebrate and preserve the heritage of America's people and places.

Find more books like this at
www.arcadiapublishing.com

Search for your hometown history, your old stomping grounds, and even your favorite sports team.

Consistent with our mission to preserve history on a local level, this book was printed in South Carolina on American-made paper and manufactured entirely in the United States. Products carrying the accredited Forest Stewardship Council (FSC) label are printed on 100 percent FSC-certified paper.

MADE IN THE USA